STYLE MOTIF AND DESIGN IN CHINESE ART

Blandford Press
Poole · Dorset

Michael Ridley

STYLE MOTIF AND DESIGN IN CHINESE ART

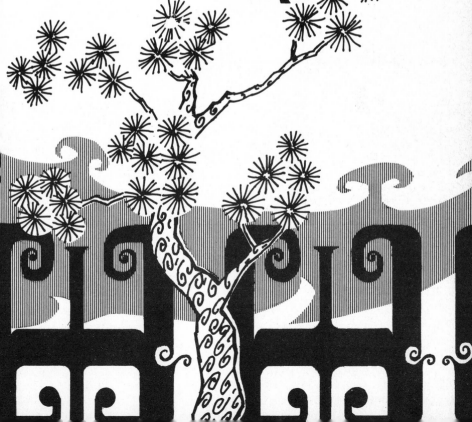

First published in Great Britain
by **Blandford Press,** Link House, West Street, Poole, Dorset. BH15 1LL

ISBN 0 7137 2502 8

First published 1977

Copyright © Michael Ridley 1977

Dolphin Studio Production

Printed and bound in Great Britain
by Biddles of Guildford

CHINESE ART

This is not a book about individual works of Chinese art, or indeed a history of the art and craftsmen of China, it is more basic than either of these themes. It deals with the basic ingredients that were used by the artists of China for thousands of years, the raw material so to speak, that were employed by artists and craftsmen working in all mediums. It deals with the language of Chinese decorative art, the art of the craftsmen and the artisans, not the scholar-painters.

The art of China is highly symbolic. It is conservative and formal. If analysed it can be broken down into a number of basic elements which appear in one form or another and in various combinations over thousands of years. It is a language that is on two levels. On one it is a decorative language employed for aesthetic reasons, and on the other it is symbolic and full of meaning; usually it is both.

However we try to analyse it, we must always remember it is art not science, and therefore rules we may apply will always tend to be broken by exceptions. Classification of elements is not absolute, designs and motifs tend to be metamorphic, changing from one to another, or themselves being formed by other elements. Each change is also a change in symbolic meaning, although meanings may be complimentary or even composite.

Chinese art is a conservative art, it has retained its overall identity over many centuries, assimilating artistic influences and ideas from many sources both inside and outside China, each idea being modified and each change, addition, innovation or invention being stored and assimilated.

The history of Chinese art begins in the Neolithic period with the decoration of pottery and the carving of jade. By the Bronze Age firm artistic principles had developed, which found expression in superb bronze ritual vessels. The indigenous tradition of abstract design and sculptural quality established in the Neolithic period laid the foundation of the vibrant, stylized, somewhat abstract yet geometrical and symetrical art of the Shang and Chou dynasties.

The ritual vessels of the Shang and Chou dynasties were cast to commemorate religious rituals and sacrifices and thus the designs and shapes were executed for that purpose. However, combined with influences from both the preceeding Neolithic period and the subsequent introduction of artistic ideas from outside China, it provided a basis from which all other artistic ideas flowed. It was the stream which grew into the river of Chinese artistic expression, fed by

numerous rivulets of modifications, innovations and artistic inventions from within and without China.

The designs and shapes of the ritual bronzes vary according to the several distinct phases which are known. During the Shang period, the decoration was exuberant and dynamic with relief designs cut deep into the bronze. Later during the Chou dynasty, the designs lost much of their force and became more controlled and tame.

Most of the designs were metamorphic, a trait that occurs time and time again in later periods. They were also composite, another feature that is common to the art of all periods. This can be seen in the stylization of the motif, which according to the style in which it is being expressed, turns geometric, abstract, or changes into another design, which is a derivative of the first and yet which itself if stylized, may revert to an expression of the original theme. By the formation of composite designs and motifs, new designs were achieved which in fact were metamorphic. This can clearly be seen in later art, where the objects are clearly recognisable, but in much Shang and Chou art this is often difficult.

Animals and birds inspired much of the early designs. They are highly stylized geometrically and it is often very difficult to identify the animal actually being portrayed.

The T'ao-T'ieh symmetrical monster-mask was an extremely popular motif as were animals, birds and insects with large eyes, such as owls, cicadas and snakes.

The T'ao-T'ieh was used in numerous versions. It is basically a geometrically stylized mask formed by the merging of two animals in profile, as if one animal had been split down the middle and opened up flat to form two. All the parts of the animal are manipulated to form the mask; the tail, legs, snout, jaws, fangs, beak and eyes and are all recognisable, if studied carefully. The Kuei dragon appears as the unsplit side section of the T'ao-T'ieh.

The practice of dismembering an animal and design, stylizing, accentuating and then reassembling it to form another design, occurs many times in many periods. What must be borne in mind is the fact that Chinese art is conservative, nothing is discarded, everything new is simply assimilated and added to the old. It is thus fascinating to break down the elements and see how they re-occur in different forms.

The idea of producing composite designs is allied to that of combining the attributes and symbolism of those designs to form one. This is a notable feature, especially with the use of auspicious symbols, both Buddhist, Taoist and other. The composite animals of the Shang and Chou dynasties were probably also intended to be endowed with the power of all.

The artistic ideas of the Shang and Chou dynasties were modified during the periods of the Spring and Autumn Annals and the Warring States. The next great event was the introduction during the Han dynasty of a barbaric realism from the Steppes. The art of the Steppe nomads had a profound affect on that of China. The stylistic exuberance of the early periods was replaced with a vibrant naturalism, with its chief expression in human and animal figures.

Indigenous philosophies and ideas, including those of Confucianism and Taoism, played a vital part in early art, or perhaps it would be truer to say that the philosophies and ideas stemmed from the same source as the artistic ideas. However, one of the most important influences on Chinese art came from outside of China, from India. For India was the birthplace of Buddhism, which not only acted as a major stimulus in the production of artistic works, but also became a vehicle of a new major artistic expression of the human form, based on the artistic style of Gupta India. Gupta influence can clearly be seen in much of T'ang art and is even seen in the art of the Nara period in Japan.

Buddhism was introduced into China in the 4th century A.D. It brought with it not only Indian ideas of artistic expression but also a fully fledged mythology which soon merged with the mainstream of Chinese thought. Thus, Buddhist auspicious symbols were added to the already large body of indigenous symbolism. Buddhism also brought with it a preference for decorative flower motifs. Thus, the basic elements of Chinese decorative art were established early in Chinese history. What occurred over the centuries was simply elaboration and adaption.

This book is a look at the elements of Chinese art. It is in no way chronological nor does it use much of the conventional terminology. This is intentional, in the hope that it will allow a fresh look at the art and enable us to see it for what it really is.

The motifs are presented classified into types and shown in metamorphic sequences of development. Themes and motifs in Chinese art continually re-occur in different periods. This is due partly to the Chinese natural conservatism and reverence of the past and partly to the fact that is is a living tradition and expression of a coherent and vibrant art. Thus as a general rule style, motif and design should not be used as a guide to period, but only considered as an expression of aesthetic ideals.

The illustrations express the essence of the theme. Each page has been arranged in groups. They can be read from top to bottom or bottom to top or from either end of the group or sequence.

There is a Chinese proverb that says "One picture is worth a thousand words". A lengthy text on a subject such as this would be

pointless and futile, and so true to the proverb, the text has been kept to the minimum, exploring the development and expression of the motifs and leaving the illustrations, aided by the detailed captions and explanations, to tell their own story and stimulate the reader into exploring the motifs on his own.

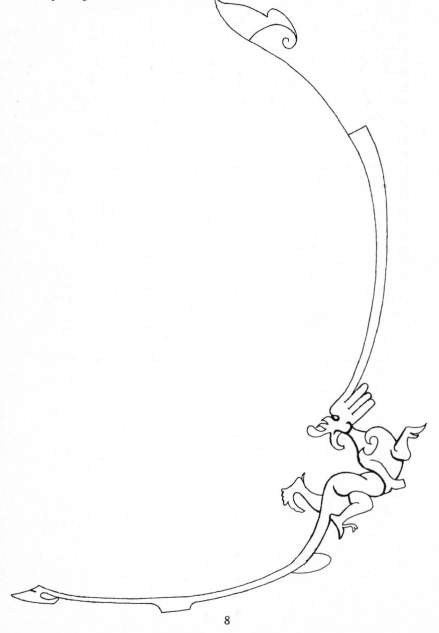

CONTENTS

34 *Top left:* Figure of an official painted on a brick. Earliest example of calligraphic technique applied to painting. Han dynasty, 2nd century A.D. *Bottom left:* Sculpture of the Bodhisattva Avalokitesvara, from Ch'ang-an, Shensi. 8th century A.D. The figure shows strong influence of Indian Gupta artistic ideas. *Right:* Mural painting of a priest, in a cave a Tun-huang, Kansu. 7th century A.D.

35 Rubbings of human figures from bricks in a Han tomb. 2nd century B.C.

36 *Top:* An unusual gilt bronze ornament in the form of men dancing unearthed at Chinning, Yunnan. Western Han dynasty (206 B.C.-A.D. 24). *Left:* Marble sculpture of the Bodhisattva Avalokitesvara, found at Sian, Shensi. *Right:* Painted lacquer toilet box unearthed at Changsha, Hunan. The box is decorated with human figures and with bands of cloud designs. 5th century B.C.

37 *Top:* Kuei dragon. *Middle:* T'ao-T'ieh monster masks from Shang and Chou archaic bronzes. *Bottom:* Kuei dragon pattern.

38 *Top:* T'ao-T'ieh and Kuei repetitive patterns. The T'ao-T'ieh design by repetition becomes a series of Kuei dragons. *Bottom:* Ritual bronze food vessel, "Kuei" of the Shang dynasty (1523-1027 B.C.) excavated from An Yang. The vessel is decorated with Kuei dragons and mythical creatures.

39 Ritual vessel decorated with 'Kuei' dragon pattern bands and with T'ao-T'ieh masks.

40 *Top:* T'ao-T'ieh mask. *Left:* Ting decorated with 'Kuei' dragons forming T'ao-T'ieh masks. *Right and Bottom:* Kuei dragons.

41 Ritual bronze vessel of the Western Chou Dynasty (1027-770 B.C.) from Chungshan, Hupeh. The earlier vibrant designs of the Shang dynasty have been controlled and tamed making the design into a geometric repeat.

42 T'ao-T'ieh and Kuei repetitive patterns, showing evolution and development of forms.

43 T'ao-T'ieh and Kuei derivatives. Here the creatures have been dismembered and re-assembled into complicated repetitive patterns, the bottom in the form of an expanded lattice.

44 Gold openwork dagger-handle composed of entwined Kuei dragons. 4th century B.C.

45 Kuei derivative patterns arranged to show the development of complicated geometric forms.

46 The Kuei dragon pattern is here further elaborated.

47 'Kuang', ritual bronze wine vessel in the form of a mythical animal and decorated on the sides with T'ao-T'ieh masks and on the base with mythical birds and animals. Western Chou dynasty (1027-770 B.C.) found at Fufeng, Shensi.

48 Mythical creatures, some stylized, some geometric to the point of forming an apparent abstract design like the bottom motif of entwined double expanded dragons. **49** Stylized mythical creatures.

50 Highly stylized mythical creatures from jades of the Shang and Chou dynasties.

51 *Top left:* Belt buckle in the form of a mythical creature. *Others:* Stylized mythical creatures from jades of the Shang, Chou and Han dynasties.

52 *Top:* Dragon or mythical creature from a brick in a Han tomb. *Top right and Centre:* Mythical creatures on tomb bricks of the Han dynasty. *Others:* Mythical creatures from jades and other objects of the Chou and Han dynasties.

53 *Top:* Bronze belt hook in the form of a mythical animal. *Bottom:* Animals of the Four Directions, often found on bronzes and lacquers of the Han dynasty. They are Tortoise with snake - North and winter; the Scarlet Bird - South and summer; White Tiger - West and Autumn; Green Dragon - East and spring.

54 Bronze 'Cosmic' mirror decorated with TLV design (i.e. design incorporating elements that resemble the letters TLV) and the Animals of the Four Directions. Han dynasty.

55 Dragons.

56 *Top:* Selection of Dragons of various periods. *Bottom:* Blue and white porcelain jar of the Yuan dynasty (1271-1638) painted with an underglaze design of a dragon and clouds between lotus petal borders; the top border containing auspicious symbols.

57 Dragons. The left medallion shows a dragon destroying mythical creatures, symbolising the defeat of evil.

58 *Top:* The Kylin or Ch'i-Lin, a metamorphic mythical creature whose more common form is as illustrated. It may also appear with horns and scales; its claws also may sometimes be replaced by cloven-feet. It is sometimes confused with the Dogs of Fo, mythical beasts usually found in pairs guarding Buddhist temples or dieties. They sometimes resemble a Pekinese dog. Porcelain and bronze examples are common. *Bottom:* Stylized dragon on a Han textile.

59 Soapstone figure of a Dog of Fo. (see 58). 19th century.

60 Mythical creature patterns arranged to show the development of complex repetitive designs. In the top examples the design is based on the head and in the bottom on the complete body, as with the Kuei dragon patterns.

61 Jade libation vessel of archaic design, decorated in carvings of mythical birds. 18th century.

62 Mythical birds, repetitive patterns, arranged to show the possibilities in stylization.

63 Stylized mythical bird designs. Here the elaboration and stylization has been taken to extreme lengths.

64 *Top right:* Mythical bird from a Han tomb brick. *Bottom:* Elaborate key or lattice pattern developed from the mythical bird design. *Others:* Mythical bird designs dating from the Shang dynasty (the ritual vessel in the form of birds) to the T'ang dynasty.

11

65 Mythical bird designs dating from the Han dynasty (top).

66 *Top:* Highly stylized bird. *Bottom:* The elaboration of the mythical phoenix with clouds.

67 Combination Bird and Floral designs, highly elaborated. *Bottom:* The back of a bronze mirror decorated with a design of phoenix and flowers. T'ang dynasty. (A.D. 618-907) found at Huhsien, Shensi.

68 Bird and Flower motifs showing to extremes of stylization.

69 Jade pendant in the form of an owl. Late Shang dynasty, 13th - 11th century B.C.

70 The cicada (an insect sometimes known as the scissor grinder) has been used as a motif on Chinese art since the Shang dynasty. It was extremely popular during both the Shang and the Chou dynasties. Apart from its realistic form it becomes highly stylized being used as a repetitive pattern as those on the right, and also sometimes assumed other characteristics like the two mask versions and sometimes combining features from masks and other insects, like the butterfly. It was a metamorphic motif which also assumed the form known as the Hanging or Rising Blade motif.

71 Various forms of stylized cicada or cicada derivatives. Four types of hanging blades are shown, three on the left and one on the right. *Top right:* An elaborate design composed of cicada, butterfly and bat, with flowers, fruit and clouds all auspicious symbols. *Bottom:* Repetitive scale designs derived from cicada but with other floral connotation. *Centre:* Semi natural cicada.

72 Cicada derivatives, forming repetitive patterns and bands. The designs are arranged to show the evolution of elaboration. They are metamorphic and could equally be classified as key, geometric, and the bottom as curvilinear (this also has cloud scrolls).

73 Kuei derivatives. The top design is an extremely complex lattice formed from the dismembered Kuei. It is repetitive and in this form is almost abstract with geometric and curvilinear overtones. *Bottom:* An "exploded" Kuei pattern which again has very strong abstract overtones and yet which is the product of extreme stylization.

74 Kuei derivative patterns arranged to show degrees of stylization along different styles.

75 The celestial beings of Buddhist mythology were often employed as decorative devices. Here are *Top:* Gandharvas or celestial musicians, and *Bottom:* Apsaras or celestial nymphs. T'ang dynasty.

76 A group of Lohans or Arhats, the saints of Hinayana Buddhism. They (or their symbols) appear as decorative motifs as well as on paintings. In Mahayana Buddhism the saints are superseded in rank by Bodhisattvas. Notice the inclusion in the painting of the dragon. Ming dynasty.

77 Apsaras and Gandharvas (see 75). T'ang dynasty.

78 Rubbings of celestial creatures from tomb bricks. T'ang dynasty.

79 Celestial creatures.

80 Abstract and curvilinear designs, derived from various sources. The top design of hanging blade type also includes the inverted cloud or Ju'i.

81 Curvilinear designs arranged to show the possible combinations of basic 'C' and scroll elements.

82 Curvilinear designs of elaborate form, showing the metamorphism into both floral and abstract inspired motifs.

83 Curvilinear designs composed of basic 'C' scroll and circular elements, showing the possible combination under abstract and geometric inspiration.

84 The 'Cloud' or 'classical Ju'i' design is an adaptation of a random curvilinear design to a conventionalised and highly symbolic use. However the expression and development of the cloud motif reverts to the curvilinear combinations and elaborations using the basic cloud element while retaining the individual identity of the motif in each of its composite or repetitive forms. The Ju'i itself is a S-curved sceptre and a symbol of authority. It is associated with the Bodhisattva Manjusri. The "Ju'i" design derives from the head of the sceptre. It resembles a heart, and is used upright and inverted both as random devices and as repetitive patterns. The Ju'i head was probably derived from the cloud motif and is therefore one and the same, having a double symbolism. The classification of pure cloud motif, and the Ju'i is difficult as we have seen they each relate to and sometimes form a composite motif. Here various combinations are shown in different degrees of combination and complexity.

85 The metamorphic nature of Chinese decorative motifs is clearly evident here when Ju'i or cloud inspired motifs combine at the top to form a geometric/curvilinear motif with cicada-hanging-rising-blade overtones and at the bottom with strong floral overtones.

86 Cloud repetitive motifs with floral embellishments.

87 Cloud patterns of extreme elaboration. The top, clouds within clouds, and the bottom elaborated with intersecting circles.

88 Key Pattern. Key patterns have evolved from geometric stylization of animal and curvilinear inspired designs. Here the development of complex key patterns is illustrated in degrees of elaboration of style.

89 Like other motifs, complex composite key patterns developed from the simple key motifs, each having metamorphic overtones with other motifs with which they could be associated.

90 Key patterns derived from geometric elaborations of other decorative devices.

91 The key pattern here becomes lattice, the top with overtones of monster masks.

92 Key derivatives. Here the key pattern has been stylized altered, and taken out of repetitive pattern to form individual motifs and devices elaborated by curvilinear devices.

93 Flowers are one of the most important decorative devices used in Chinese art and occur in many forms in most periods. An example of the use of floral motifs can be seen in this white porcelain vase, of the Sung dynasty (A.D. 960-1280) which is decorated with a band of free flowing flowers and leaves.

94 Flowers - various forms of stylization.

95 Fa-hua porcelain vase decorated with flowers and butterflys. At the top flowers are included in a cloud collar border. Ming dynasty, late 15th century.

96 Flowers - various forms of stylized motifs. The flower on the bottom left includes a Yin-Yang centre (see p. 144).

97 Flowers showing various degrees of sylization. In some the flower also has the shape of a butterfly and in others incorporates cloud or Ju'i symbols.

98 Various styles of flower motifs.

99 Various styles of flower motifs.

100 Porcelain octagonal ewer painted in underglaze blue with panels of floral motifs. Other motifs include plantain leaves on the neck, a key border - also on the neck, lotus panels containing flaming pearls (see p. 144), curvilinear motif around shoulder, base and spout. Yuan dynasty (1271-1368). Found at Paoting, Hopei.

101 A blue and white large covered jar with floral design. Additional motifs include a key pattern around the neck, a cloud collar - also on the neck, lotus petal border on shoulder and base and another cloud collar midway which contains within it floral motifs. Yuan dynasty (1280-1368).

102 Floral motifs of varying degrees of elaboration.

103 Floral designs.

104 Elaborate floral corner devices composed of lotus, chrysanthemum and other blossoms.

105 Composite elaborate floral panels.

106 Composite elaborate floral panels.

107 Composite elaborate floral panels.

108 Composite elaborate floral panels, the lower two highly stylized so as to form a complex curvilinear design.

109 Floral borders. The penultimate bottom example contains additional symbolic devices of conjoined pairs of cloud or Ju'i motifs.

110 Floral borders. Here the stylization has evolved along different lines forming geometric abstract patterns.

111 Floral motifs.

112 *Top:* Circular red lacquer dish, carved with peacocks among tree paeonies. Ming dynasty, 14th century A.D. *Bottom:* Cylindrical red lacquer box, carved with camellia sprays and floral scrolls. Ming dynasty, 15th century A.D.

113 *Top:* Complex floral motif within rectangular border. *Bottom:* Circular floral motif, similar to that used on lacquer (see 112) but also used on porcelain.

114 Composite floral motifs, the lower example incorporating a curvilinear central medallion.

115 Composite floral motifs.

116 Composite floral motifs and medallions.

117 Combination motif of bird and flowers. The bottom having a curvilinear border symbolic of fire.

118 *Top:* Circular medallion containing a complex design combining flowers arranged as curvilinear devices combined with key lattice. *Bottom:* Composite motif of flowers and auspicious symbols.

119 Complex design utilizing geometric, floral and stylized mythical creature motifs.

120 Curvilinear motifs. The *top:* cloud medallion formed out of cloud or Ju'i symbols but with floral overtones. The *bottom:* stylized mythical creature with curvilinear body and with floral and negative overtones.

121 Cloud motifs as repetitive overall patterns and as lattice border.

122 Cloud devices, some containing auspicious symbols such as the endless knot (top right), cash (middle right) cash (middle left) and symbol of long life (fourth down on left). *Centre:* Porcelain vase decorated in underglaze blue decorated with cloud motifs. Ming dynasty (1368-1644).

123 Cloud motifs, some containing auspicious symbols. *Bottom:* Cloud lattice.

124 Composite design formed from clouds, stylized flowers and birds. *Bottom:* Cloud motifs.

125 Auspicious symbols. *Top:* Composite of bat, symbol of happiness, also associated with long life and prosperity; peach associated with longevity; and cash one of the Eight Precious Things. *Centre:* Butterfly symbol of happiness and conjugal felicity. Three contain the Shou character of Long Life. *Bottom:* Border of Bat, Shou characters and clouds.

126 Symbols of Long Life - the Shou character with embellishments.

127 *Top:* Shou character surrounded by cloud motifs. *Middle:* Shou character and mythical animal. *Bottom:* Border of two forms of Shou character.

128 The phoenix is thought of by the Chinese as the King of Birds (Feng). The mythical bird is a male symbol and associated with fertility. There are four types known in Chinese mythology. In some representations it has feathers similar to the peacock and is referred to as such. Although shown here in pairs they are (in legend) never seen together.

129 Phoenix and flower motif. *Bottom:* Medallion of a crane holding a peach. The crane is another symbol of longevity, as is the peach. In this form it symbolizes the soul of the dead being conveyed to heaven and as such was often used at funerals.

130 Auspicious symbols. *Top:* Ju'i sceptre, with chrysanthemum - symbol of happiness, and peach symbol of longevity. Other devices are similar.

131 Two Fishes. Various forms of the two fish motif, one of the Eight Buddhist Symbols. Occasionally they are shown suspended as in two cases on this page, by the musical stone (the L shaped object) one of the Eight Precious Things.

132 Composite auspicious motifs. The top shows kylins and clouds surrounded by the Eight Taoist Symbols. The others show various combinations of the Eight Precious Things, Eight Taoist Symbols and the Eight Buddhist Symbols, especially the two fishes as well as the bat and chrysanthemum. The bottom motif also has a Shou character in the centre.

133 Auspicious symbols in various combinations. *Top right:* is the brush, ink stone and Ju'i sceptre. A "rebius" reading meaning "May it be fixed as you wish". *Bottom:* Composite design of some of the Eight Precious Things.

134 Taoist and Buddhist Symbols. For full description of these see 138, 139, 140.

135 Auspicious symbols.

136 The endless knot, one of the Eight Buddhist Symbols.

137 Variations of the endless knot.

138 The Eight Buddhist Symbols. *From left to right:* The Conch Shell; The White Parasol; The Standard; The Two Fishes; The Lotus; The Vase; The Endless Knot; The Wheel.

139 The Eight Buddhist Symbols - stylized. *From left to right:* The Conch Shell; The White Parasol; The Standard; The Two Fishes; The Lotus; The Vase; The Endless Knot; The Wheel.

140 Top Group: The Eight Precious Things. *Left to right:* The Jewel; The Cash; The Open Lozenge with ribbons, symbol of victory; The Solid Lozenge with ribbons (or painting); The Musical Stone; A Pair of Books; A Pair of Horns; The Artemisia Leaf. **Third Row** - The Eight Taoist Trigrams - ancient system of divination. **Fourth and Fifth Rows -** The Eight Taoist Symbols. *Left to right:* The Fan; The Sword; The Gourd; The Castanets; The Flower Basket; The Drum (bamboo tube); The Flute; The Lotus. **Bottom Three Rows -** The Twelve Symbols. *Left to right:* The Sun, symbol of Heaven and enlightenment; The Constellation, of Heaven and enlightenment; The Moon the same as for Sun and Constellation; The Mountains symbolic of Earth and of protection; The Dragon symbolic of adaptability; The Pheasant symbolic of literary achievement; The Bronze Sacrificial Cups symbolizing filial piety; The Water Weed symbolic of purity; Grain, of

abundance for the people; Fire symbolic of brilliance; The Axe symbol of punishment; The Fu, symbol of Justice. The latter two could only be used by the Emperor, who was also the only person entitled to use all twelve, which symbolized Ruler of the Universe.

141 Auspicious symbols.

142 Cloud of Ju'i symbols. A metamorphic arrangement. In the centre is the Ling Chih or sacred fungus which is formed by the Ju'i or cloud symbol.

143 Variations of symbols previously described (see 138, 139 and 140).

144 Auspicious symbols. *Top left:* The Flaming Pearl. *Third row left:* the Shuang-hsi character of 'two fold joy'. *Centre:* The Yin-Yang symbol representing the balance of the male and female principles, the cosmological balance of the Universe.

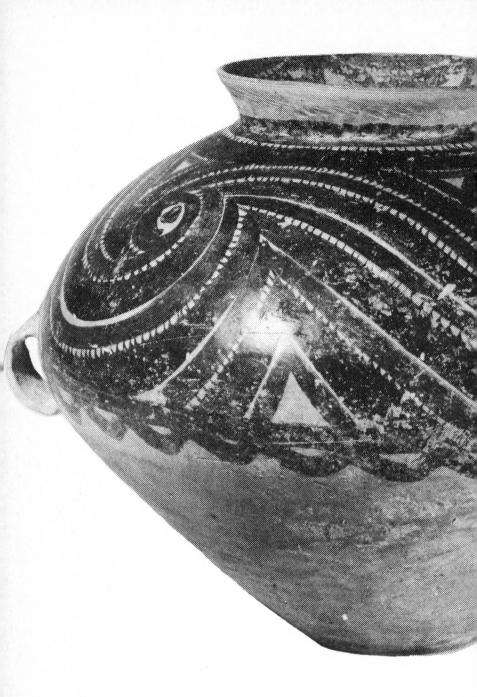

NEOLITHIC
SHAPES

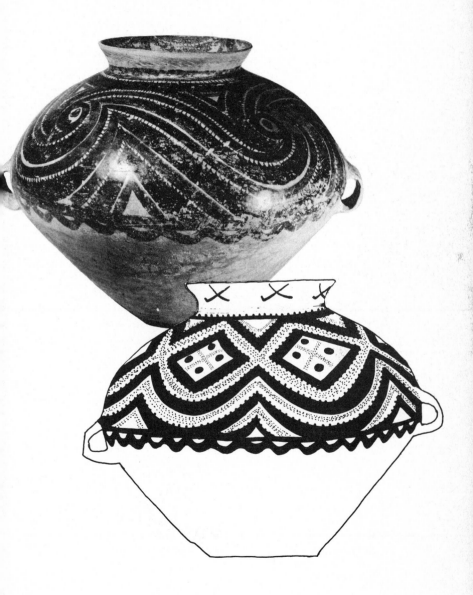

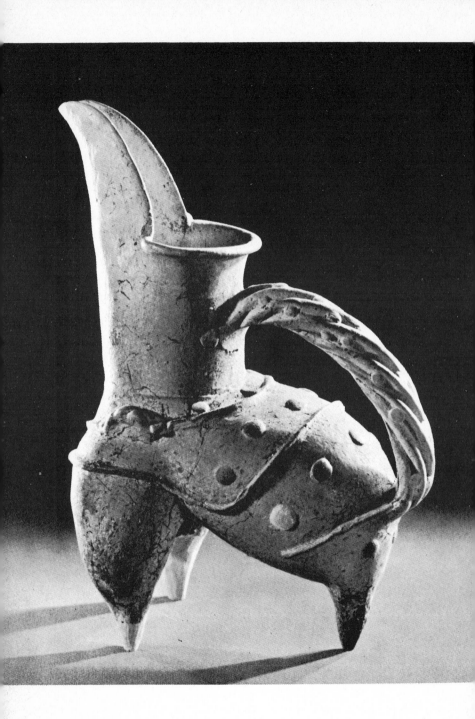

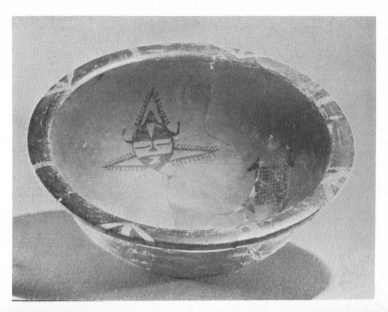

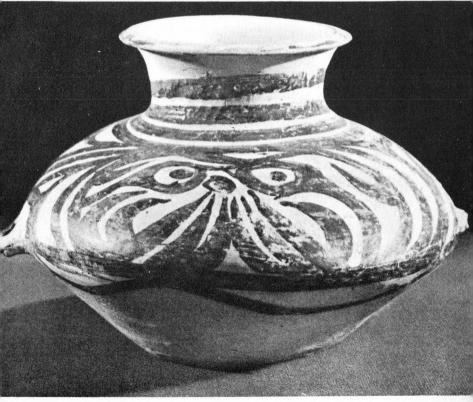

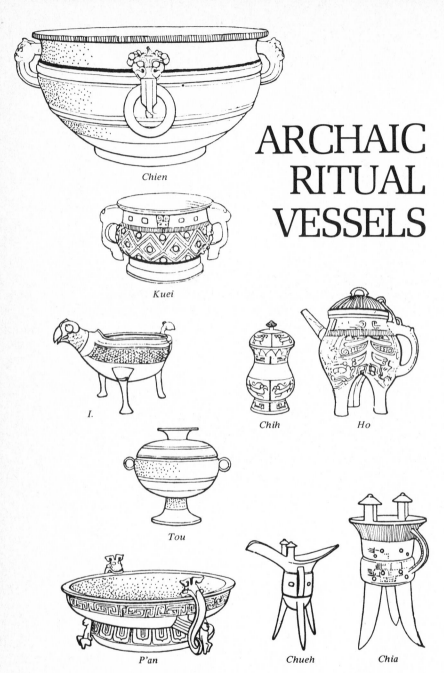

Chien

Kuei

I.

Chih

Ho

Tou

P'an

Chueh

Chia

ARCHAIC RITUAL VESSELS

Some of the shapes of ritual bronze vessels in use during the Shang and Chou dynasties.

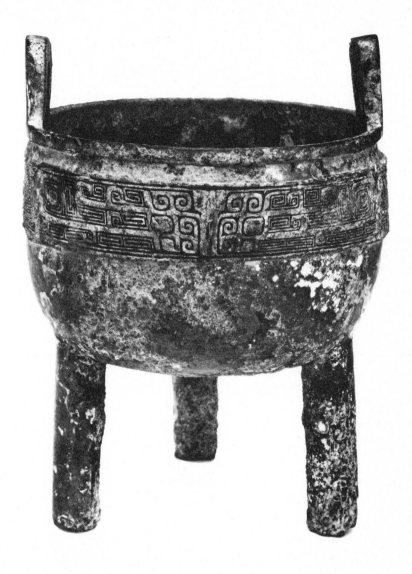

The "Ting", a ritual bronze tripod cauldron food vessel. This one dates to the Shang dynasty (1523 – 1027 B.C.)

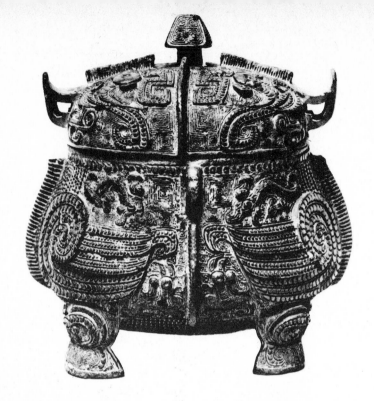

Fantastic bronze wine vessel, "Yu" in the shape of an owl. Shang dynasty (1523–1027 B.C.).

Bronze food container, "Kuei", found at Tunhsi, Anhwei.

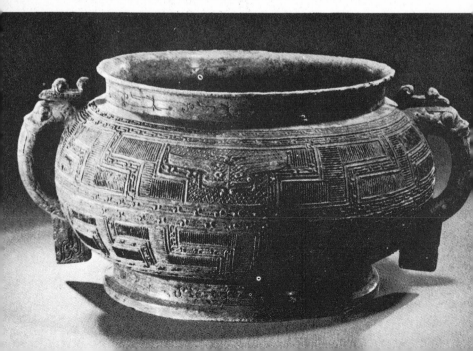

FIGURATIVE
MOTIFS

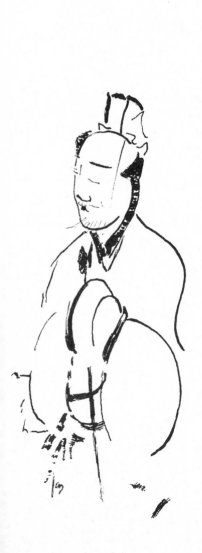

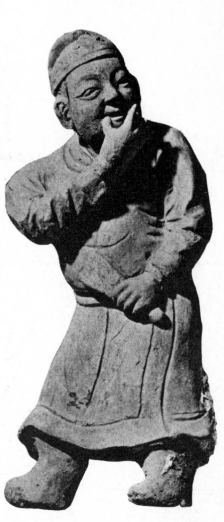

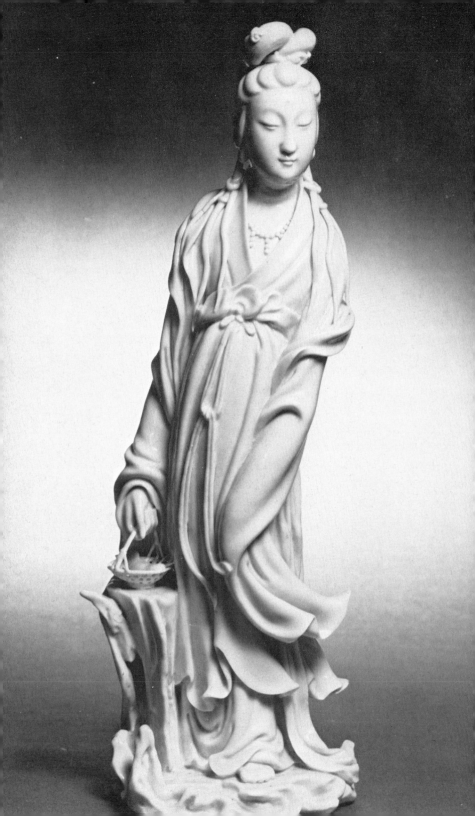

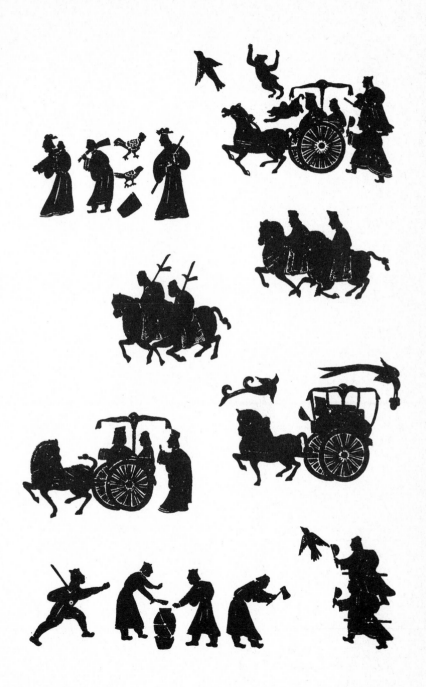

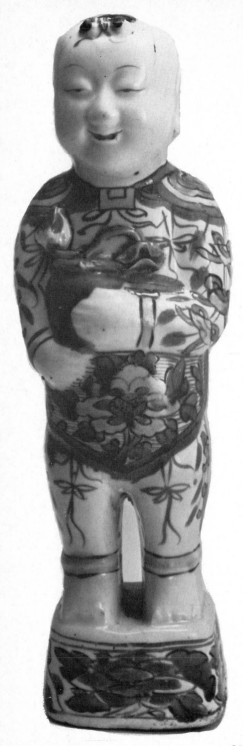

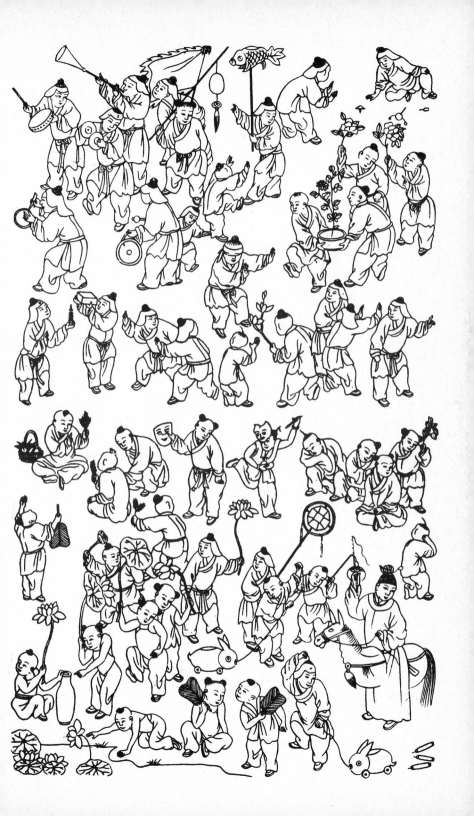

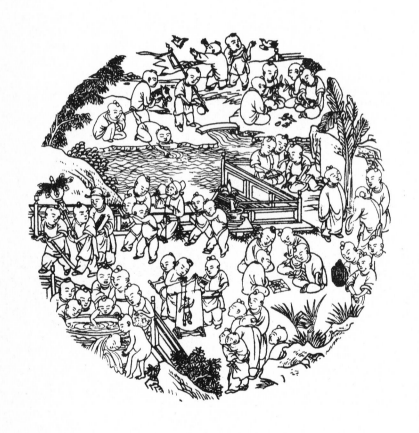

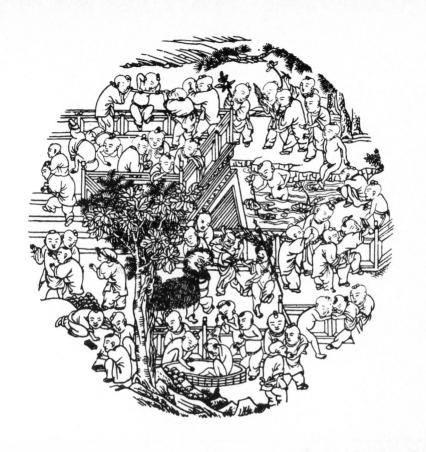

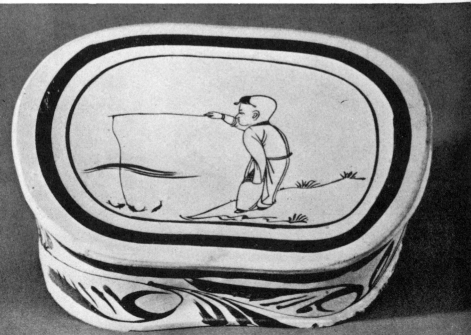

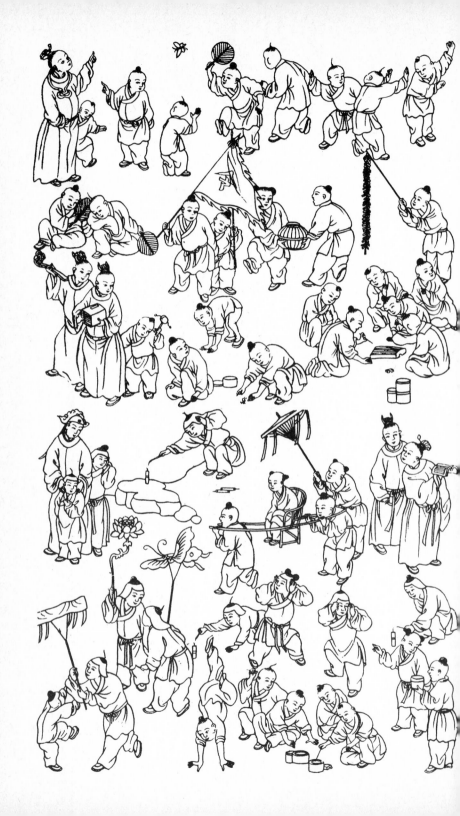

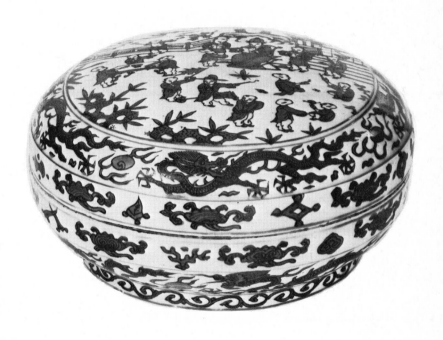

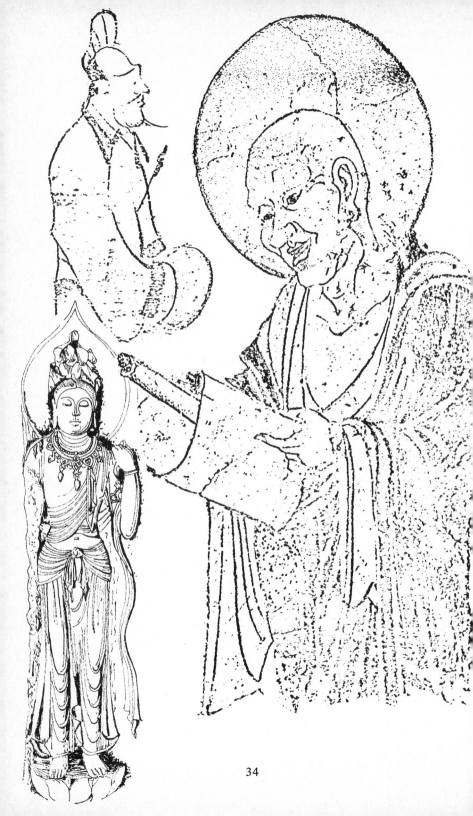

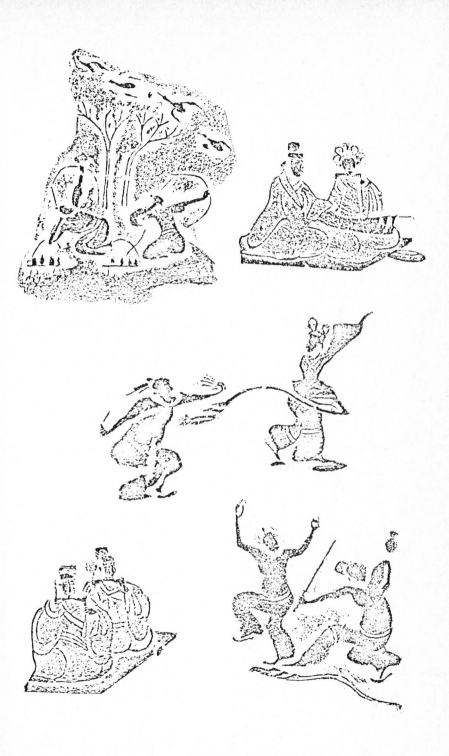

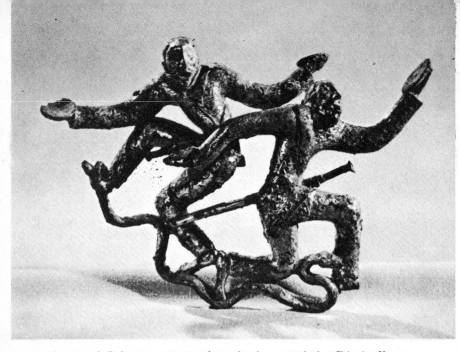

An unusual gilt bronze ornament of men dancing, unearthed at Chinning Yunnan. Western Han dynasty (206 B.C.—A.D. 24).

Marble sculpture of the Bodhisattva Avalokitesvara, found at Sian, Shensi.

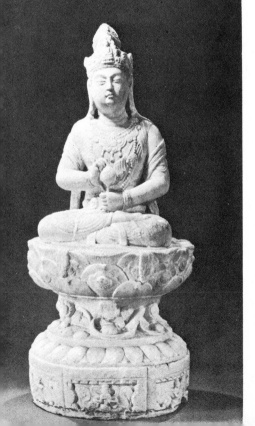

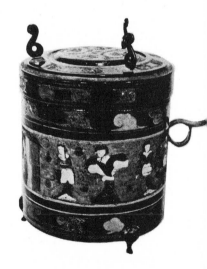

Painted lacquer toilet box unearthed at Changsha, Hunan. 5th century B.C.

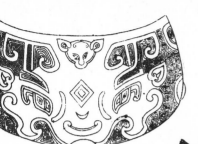

TAO-TIEH
& KUEI

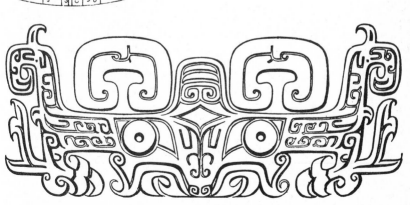

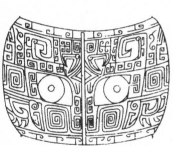

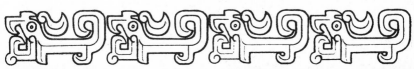

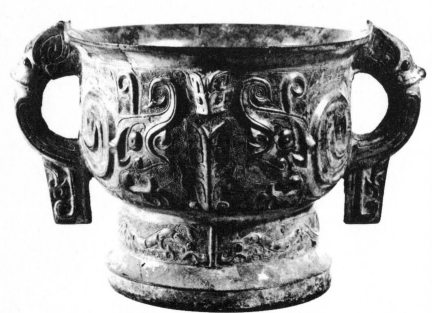

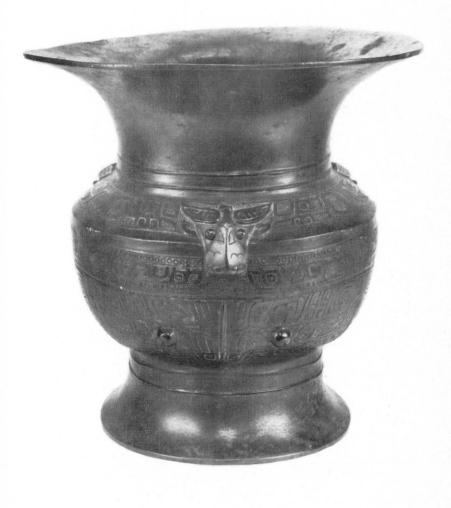

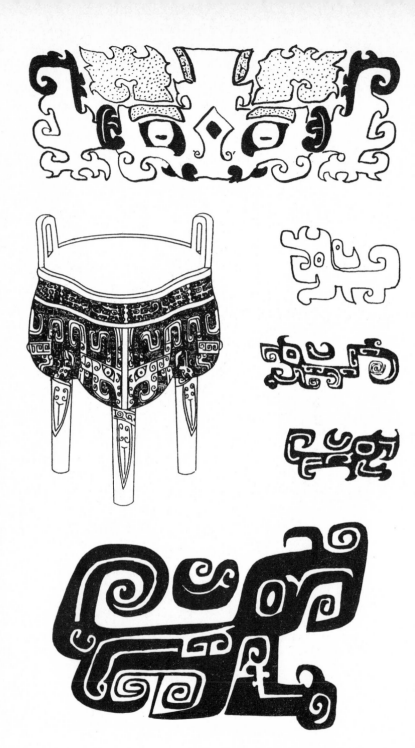

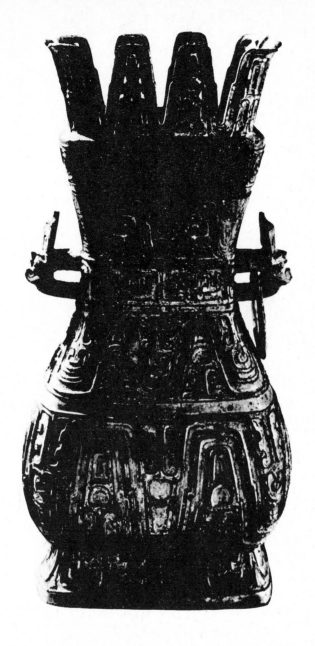

A ritual bronze vessel unearthed with others in July 1966 at Chingshan, Hupeh. Western Chou dynasty (1027–770 B.C.).

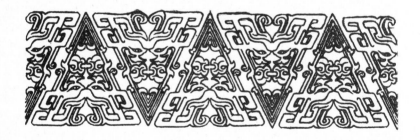

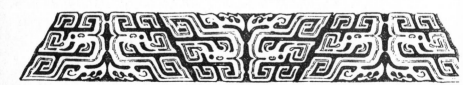

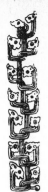

Tao-Tieh & Kuei
Derivatives

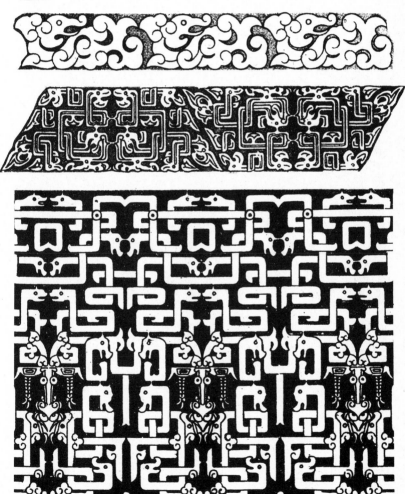

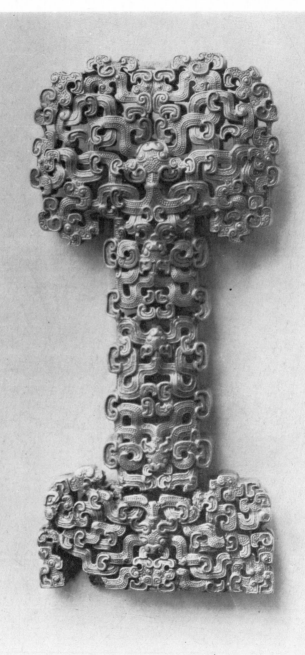

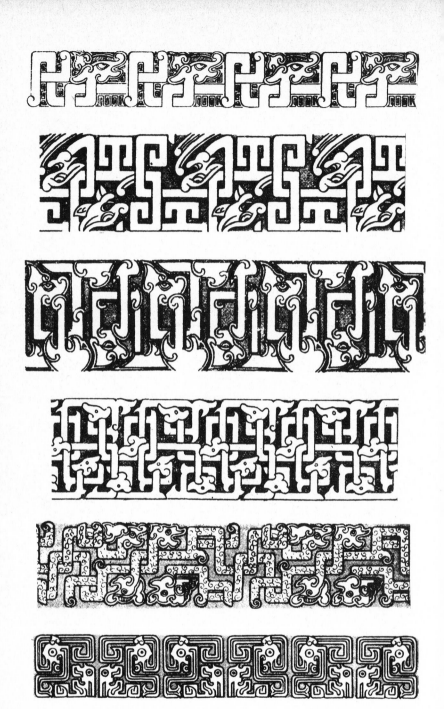

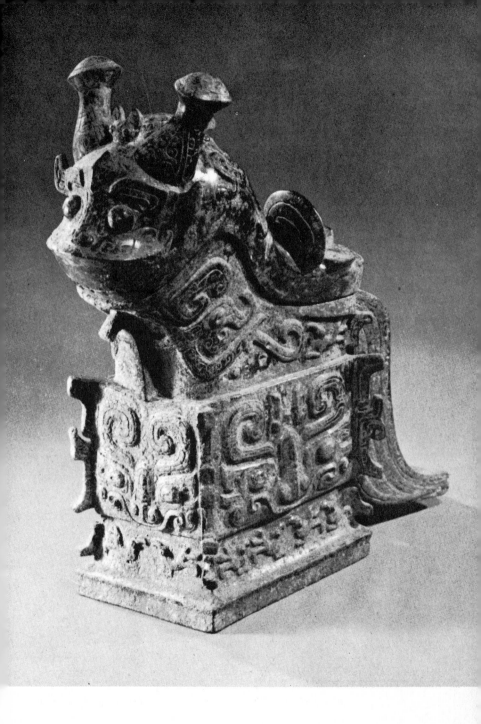

MYTHICAL CREATURES

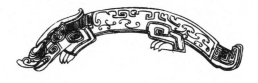

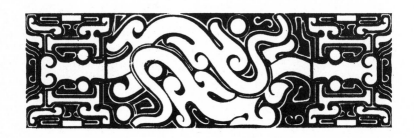

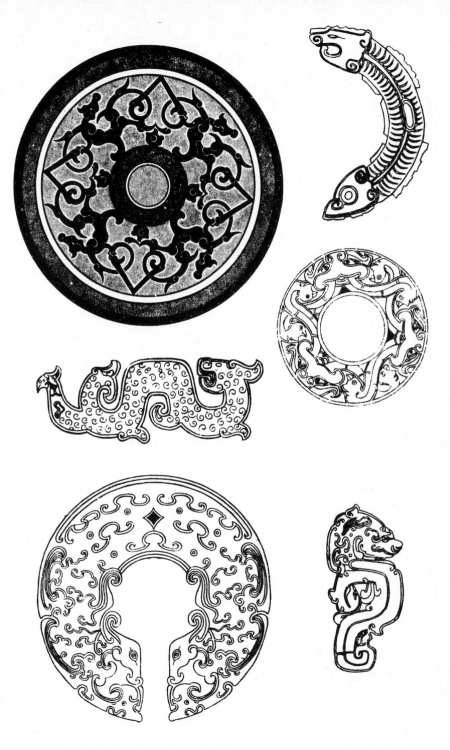

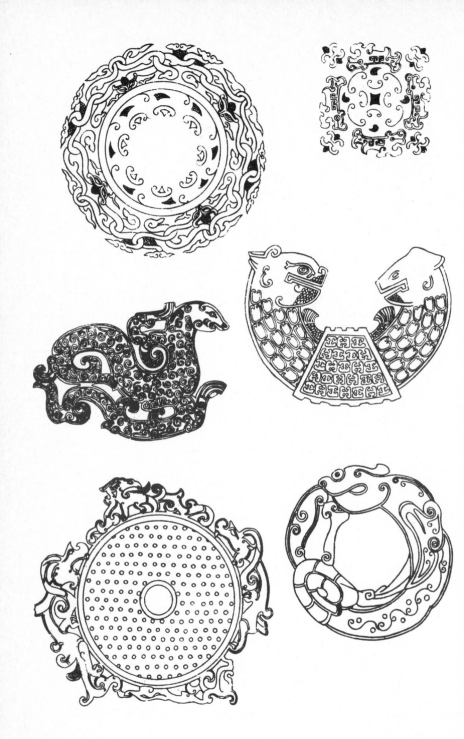

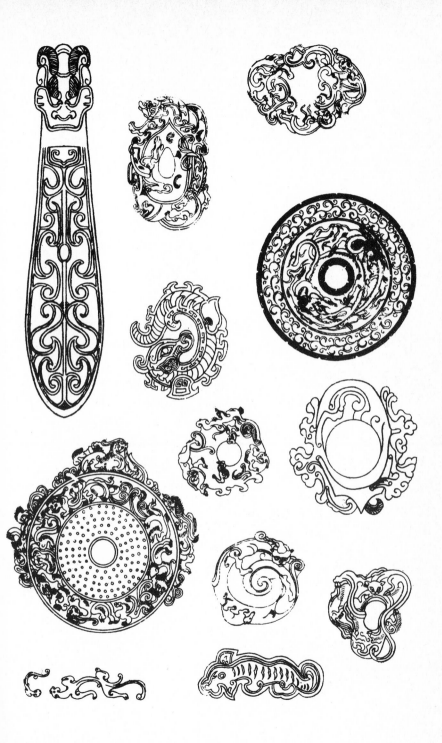

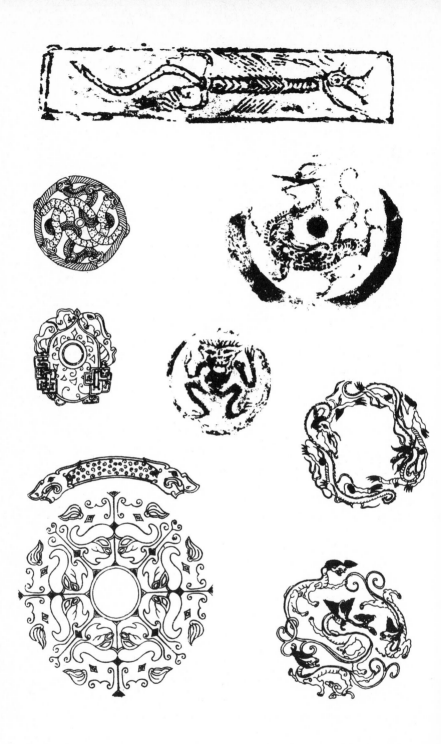

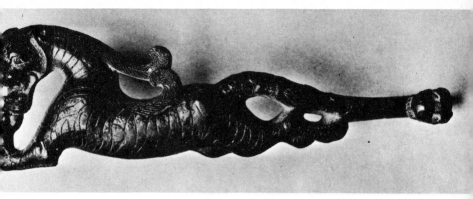

Bronze belt hook in the form of a mythical animal.

Animals of the Four Directions

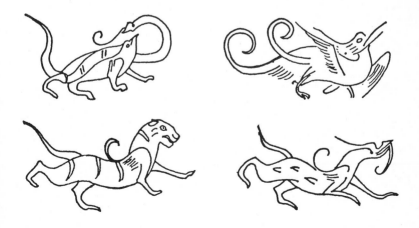

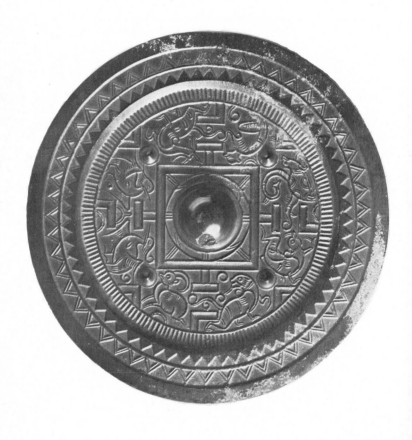

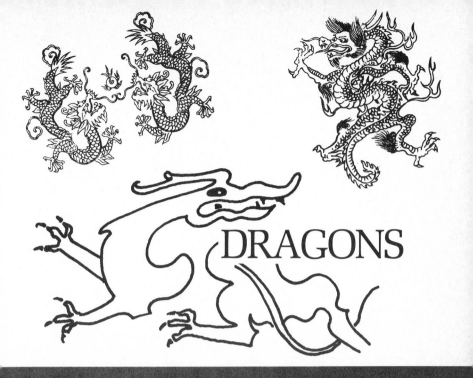

DRAGONS

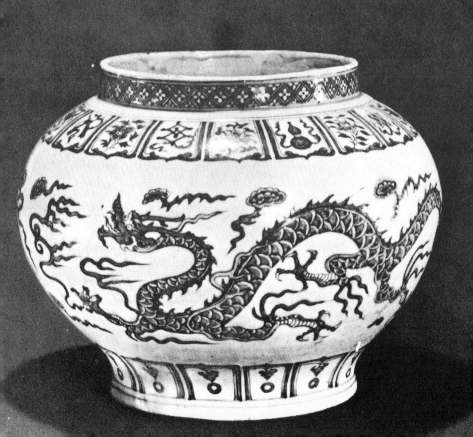

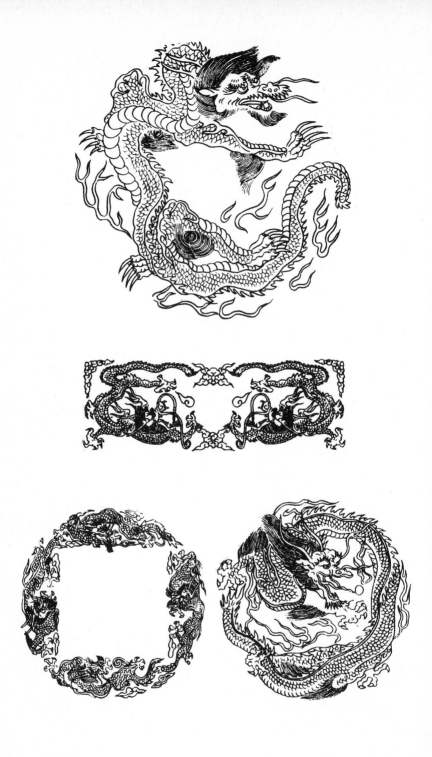

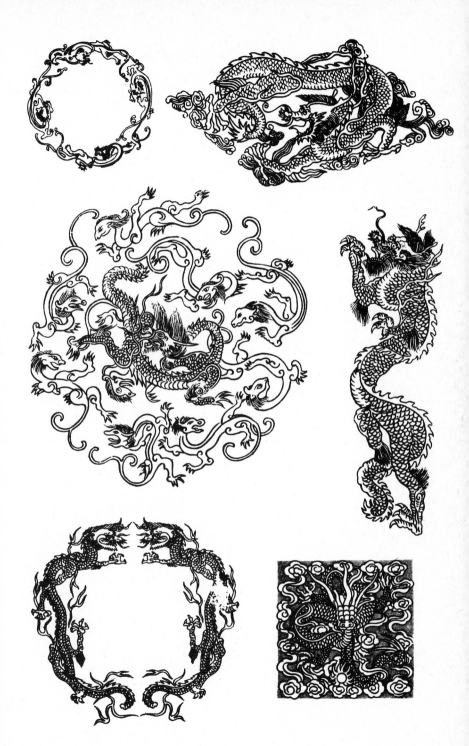

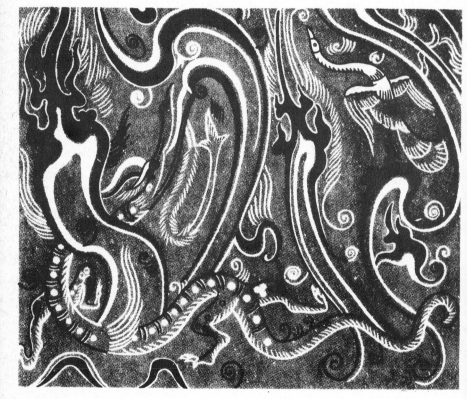

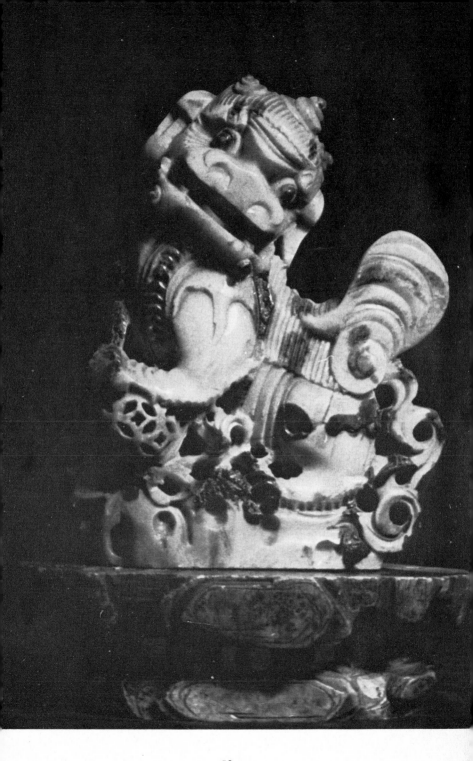

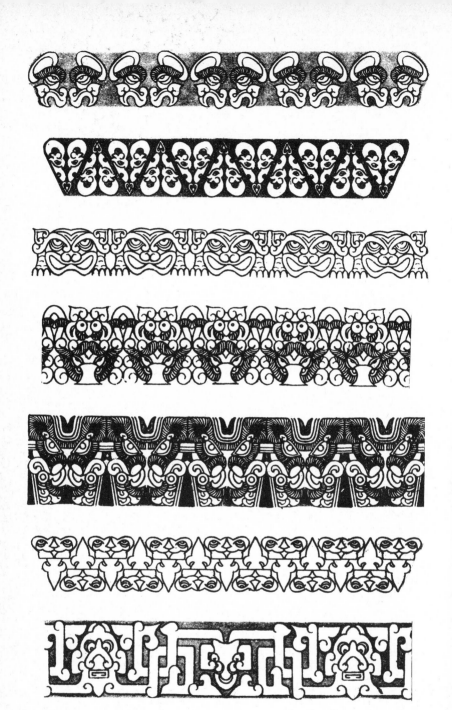

MYTHICAL BIRDS

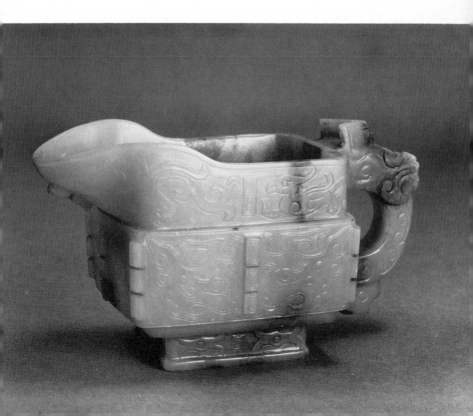

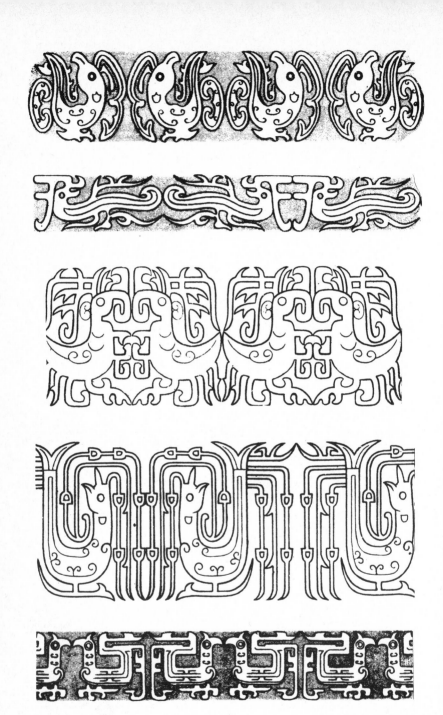

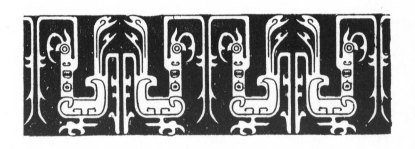

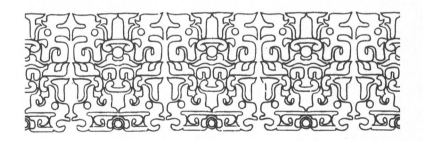

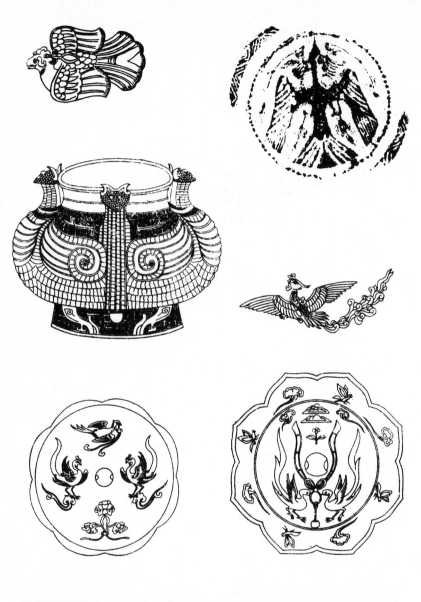

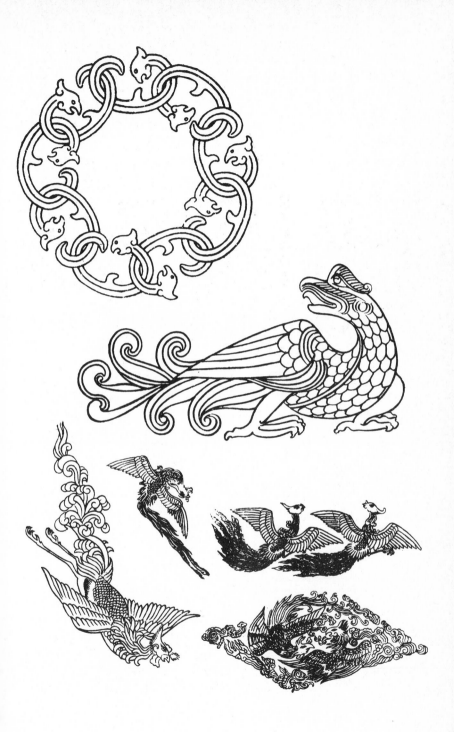

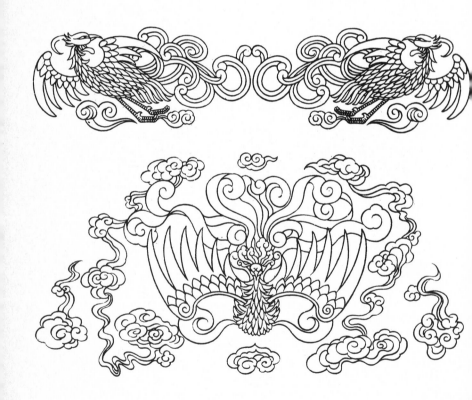

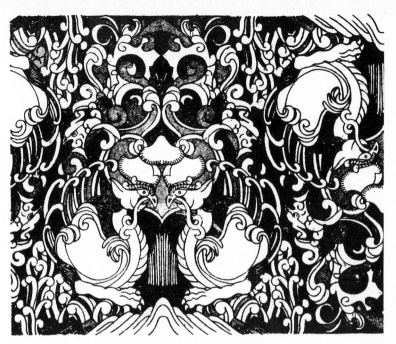

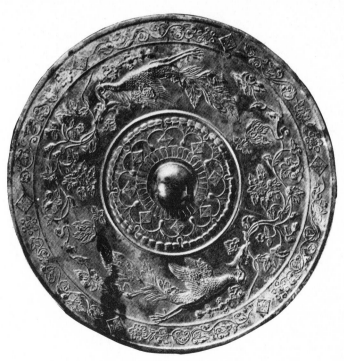

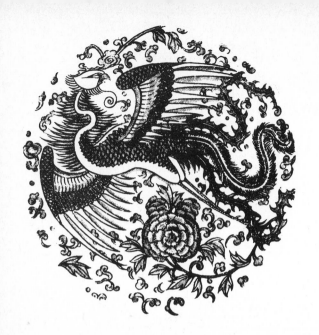

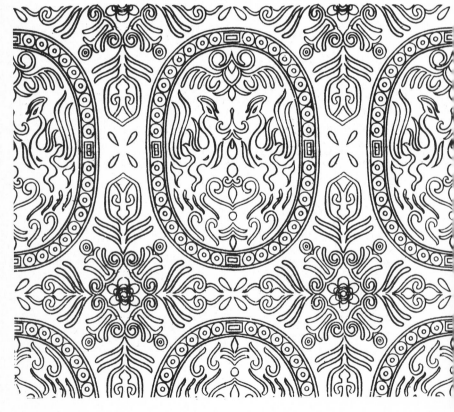

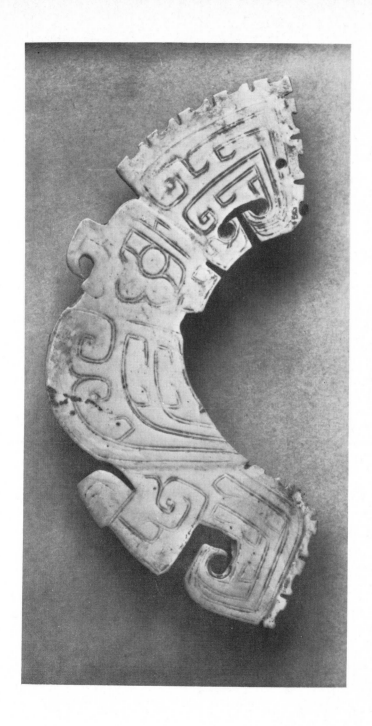

CICADA

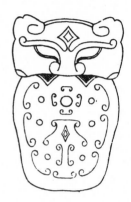

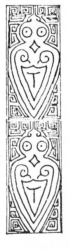

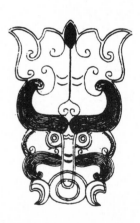

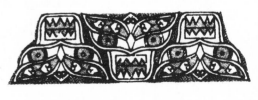

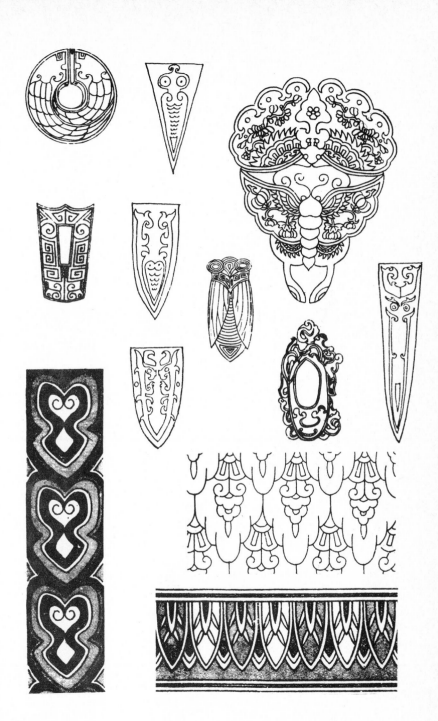

CICADA DERIVATIVES

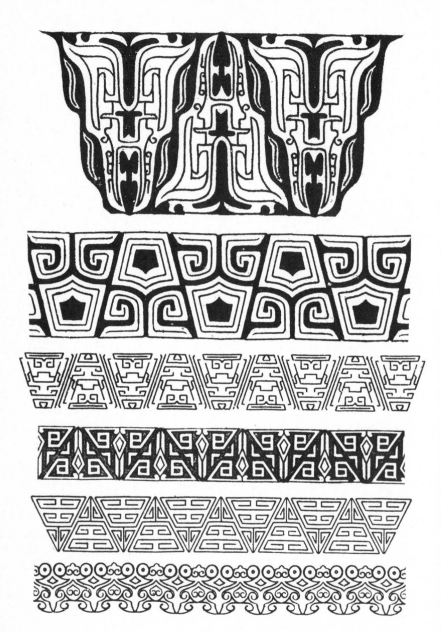

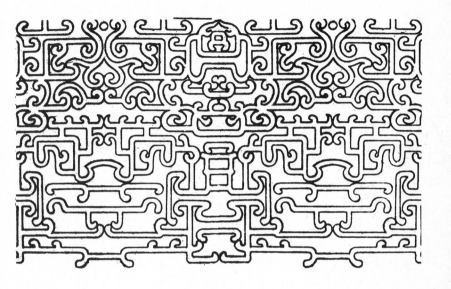

KUEI DERIVATIVES

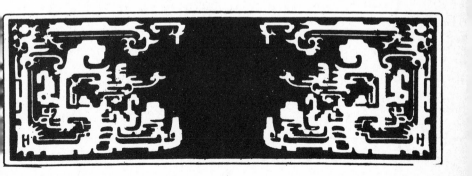

BUDDHIST DESIGNS

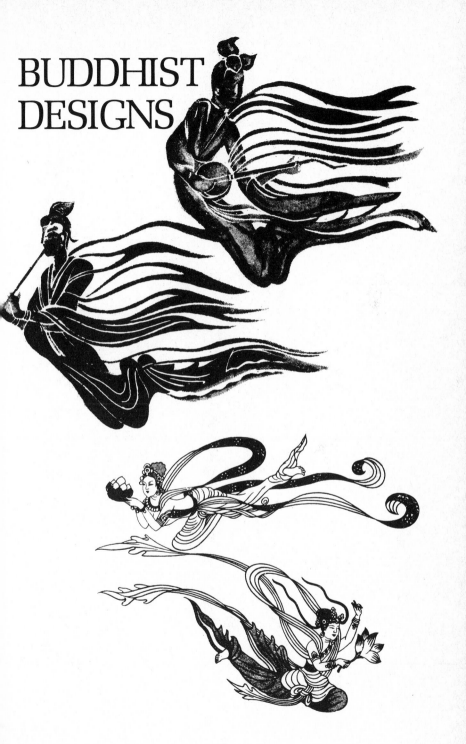

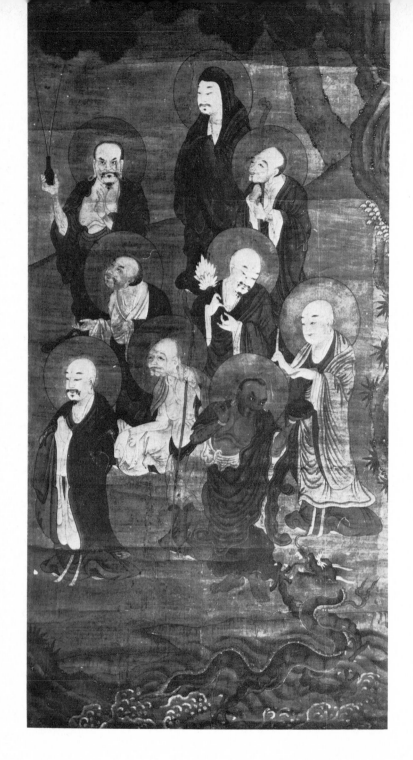

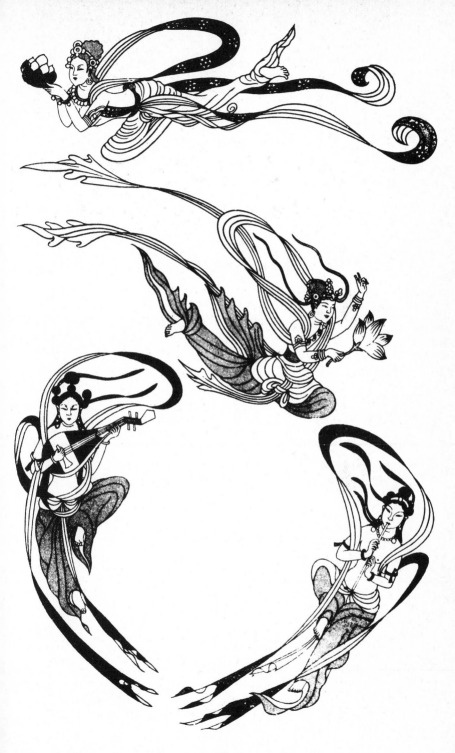

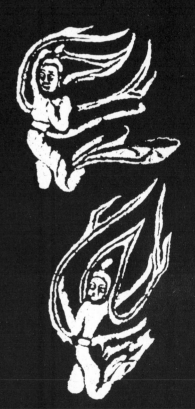

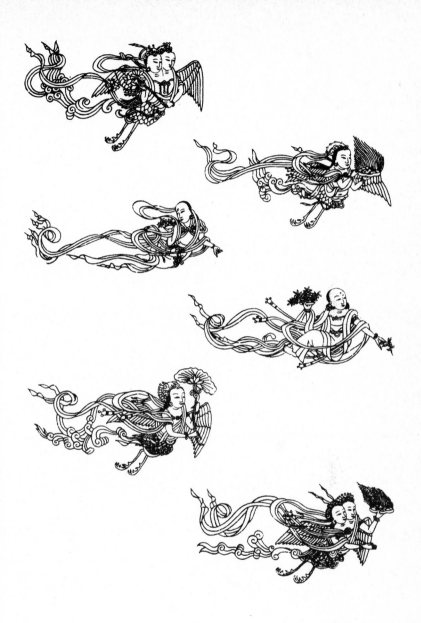

ABSTRACT AND
CURVILINEAR DESIGNS

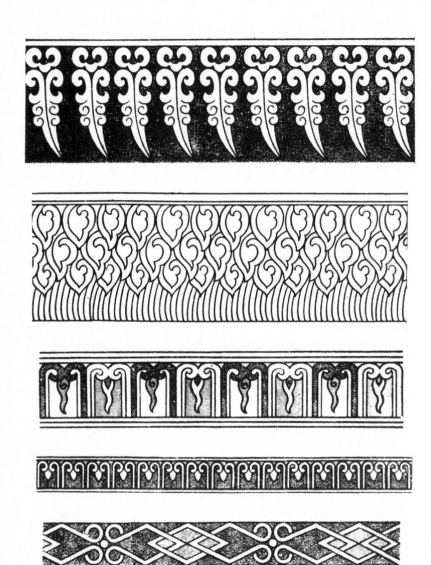

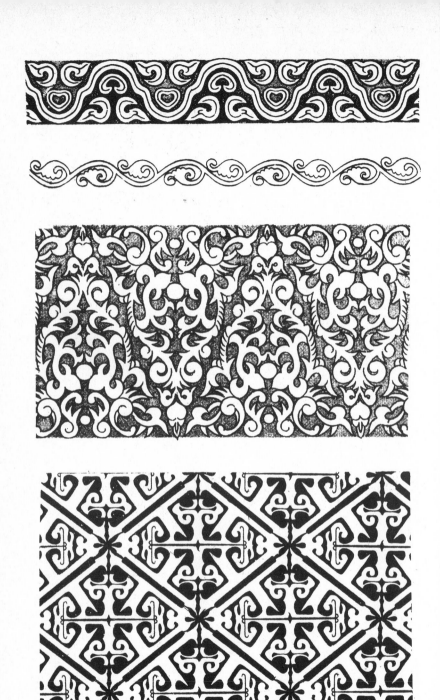

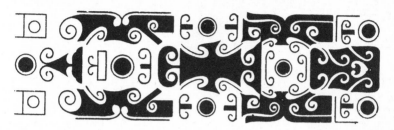

CLASSICAL "JUI" AND CLOUD DESIGNS

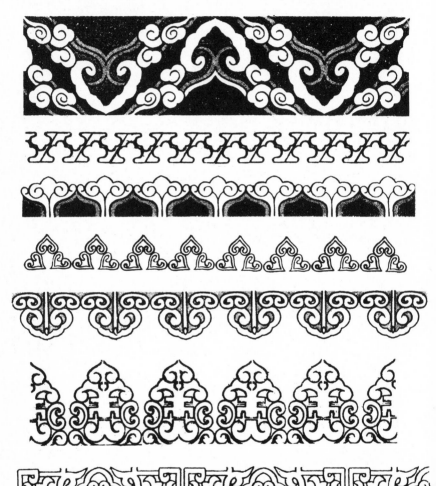

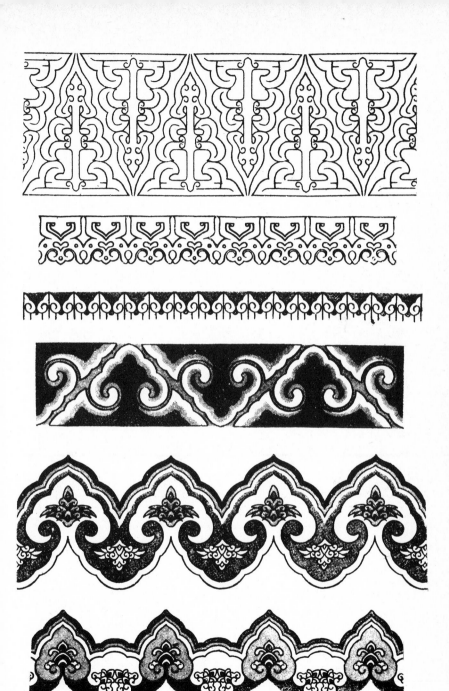

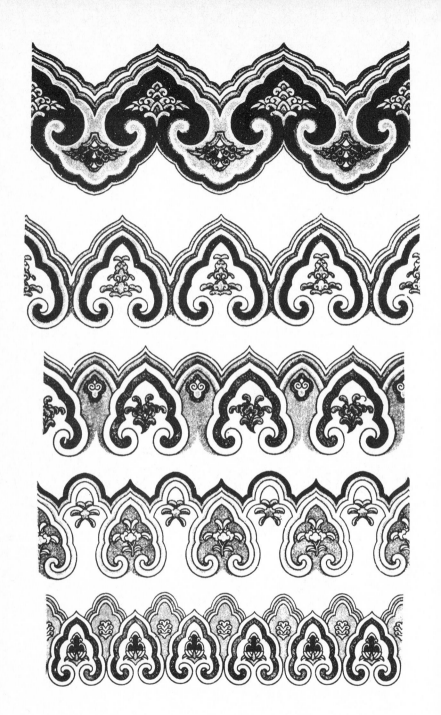

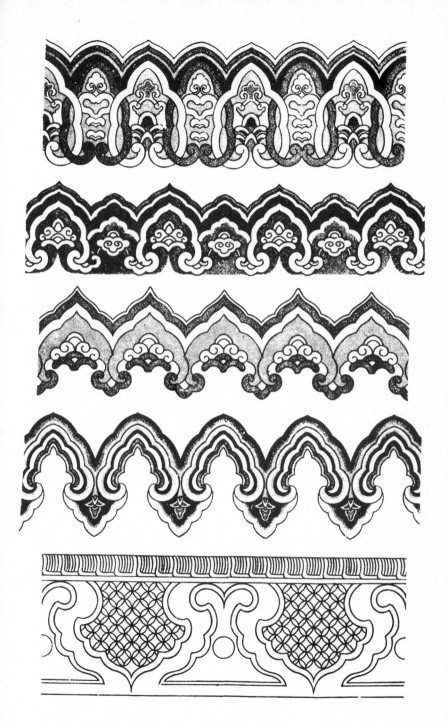

KEY PATTERNS

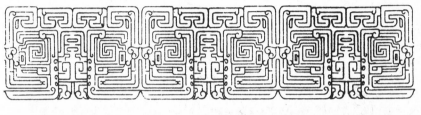

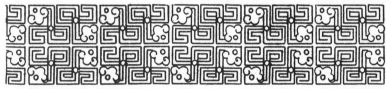

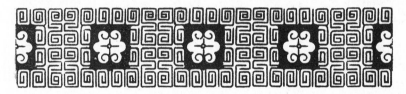

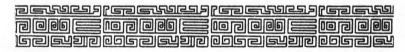

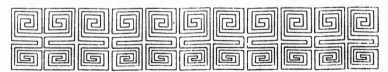

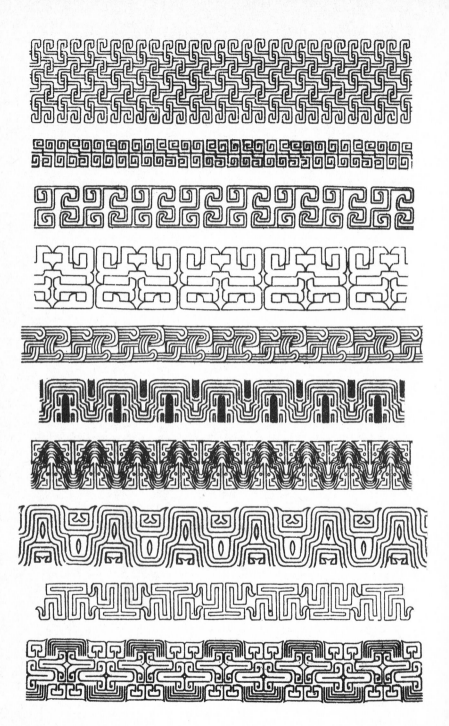

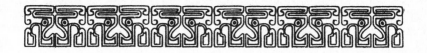

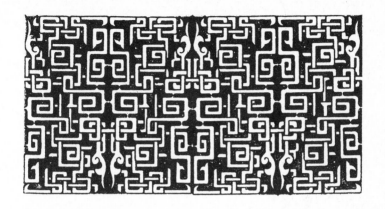

Key Derivatives

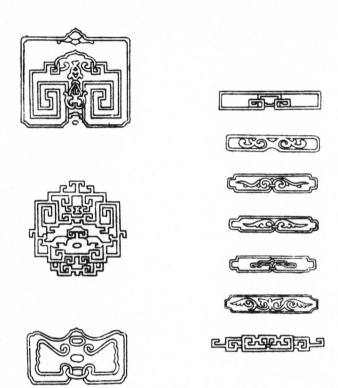

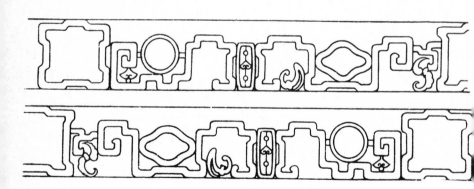

FLOWERS

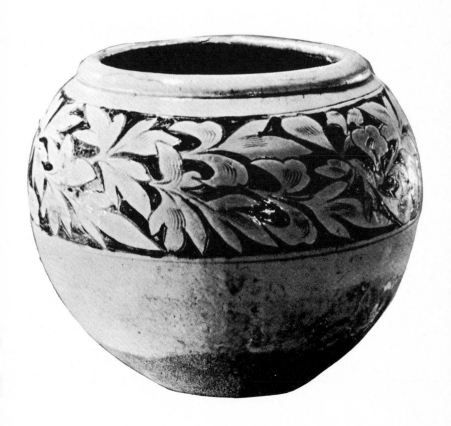

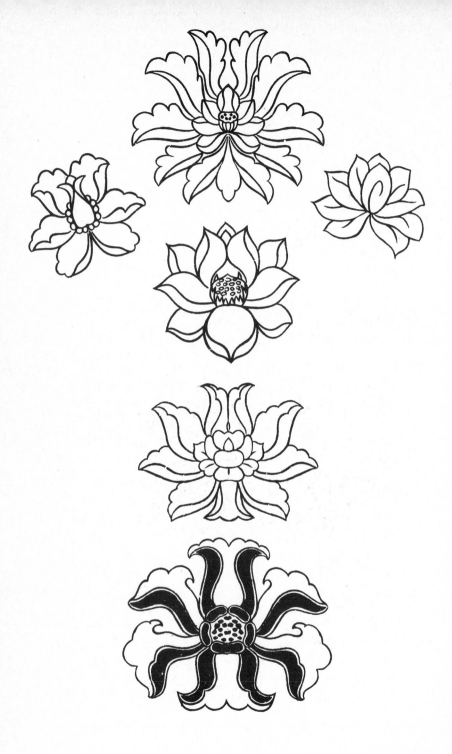

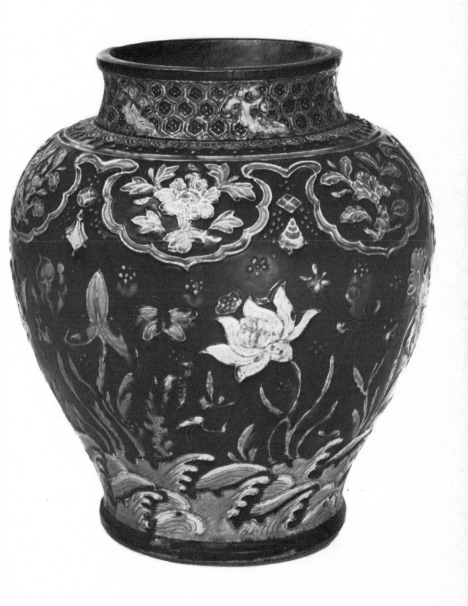

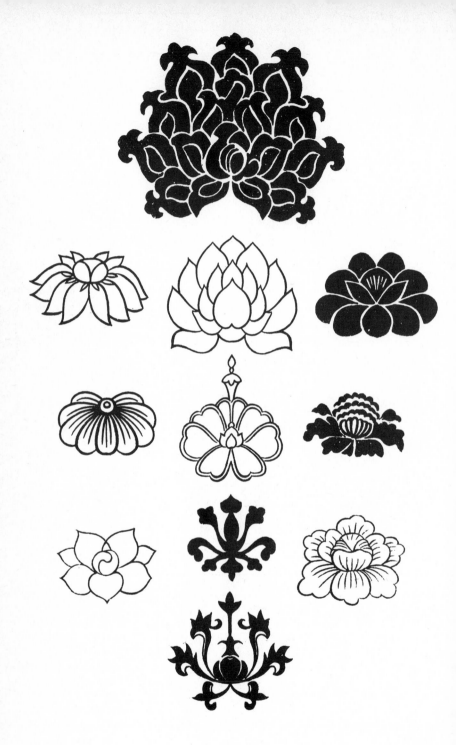

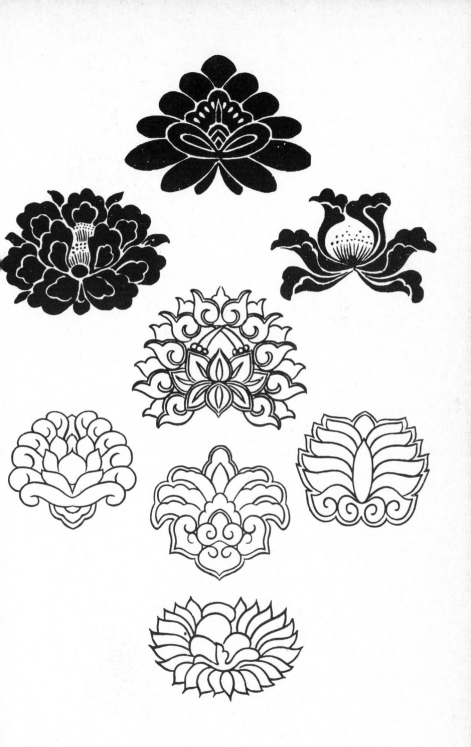

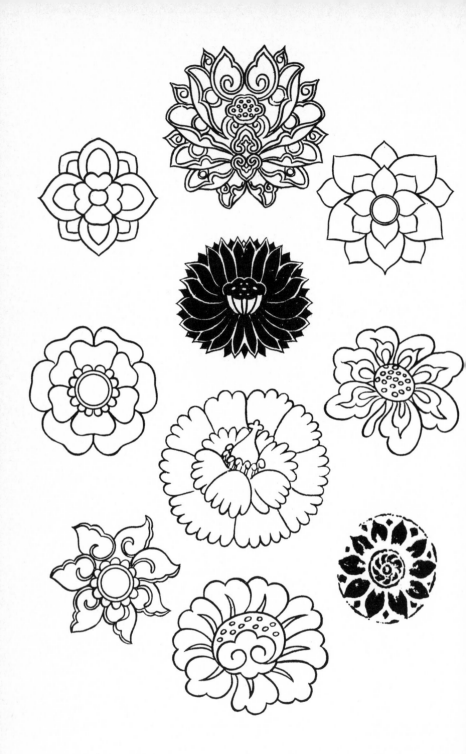

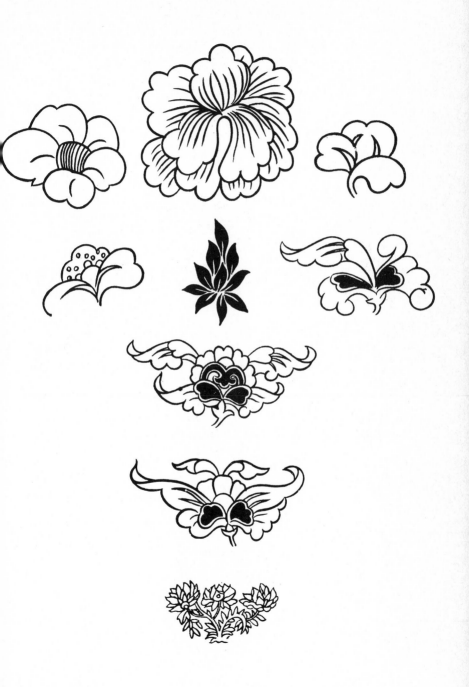

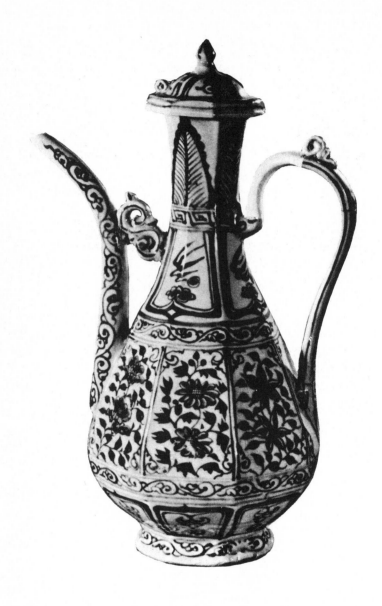

Porcelain octagonal ewer painted in underglaze blue with a floral design. Yuan dynasty (1271–1638). Found at Paoting, Hopei.

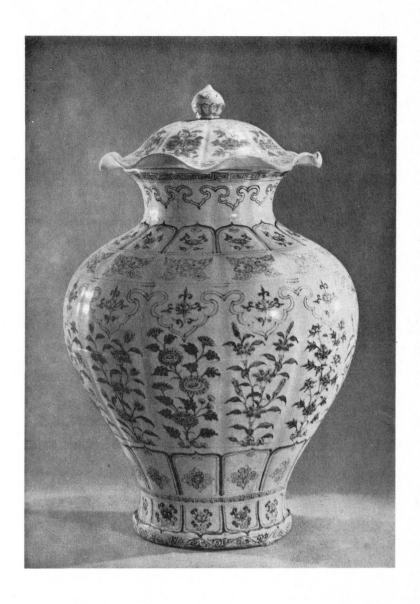

A blue and white large covered jar with floral design, found at Peking. Yuan dynasty (1280–1368).

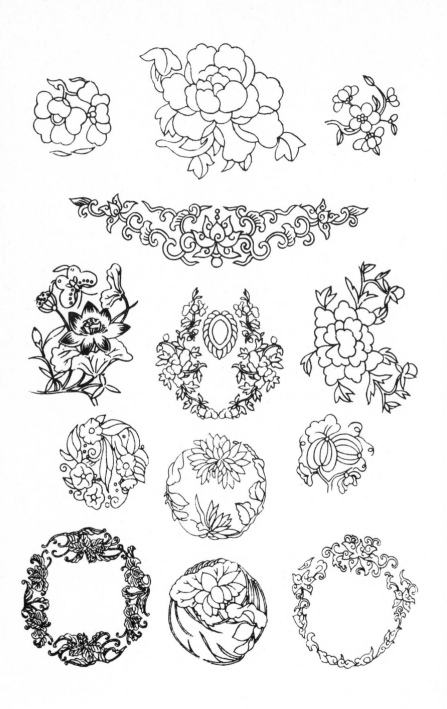

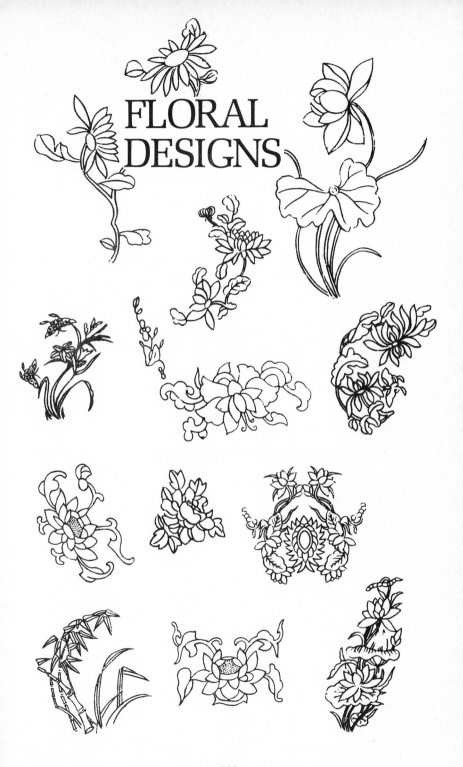

FLORAL DESIGNS

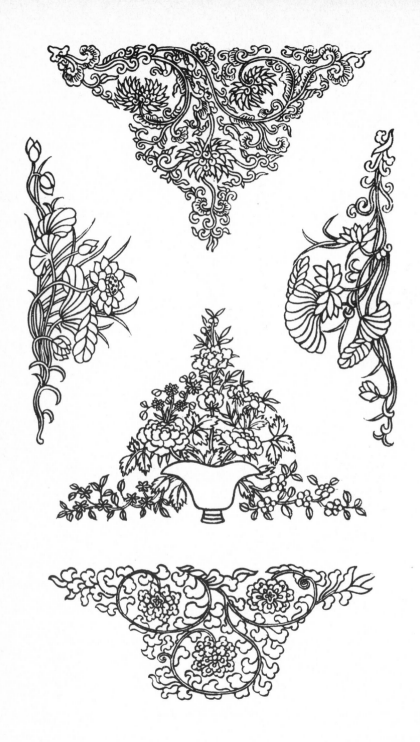

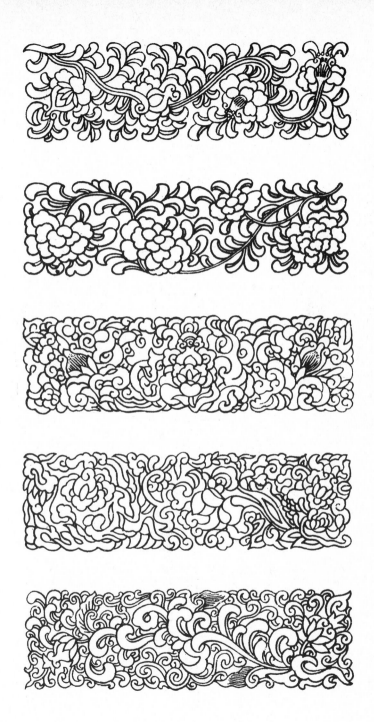

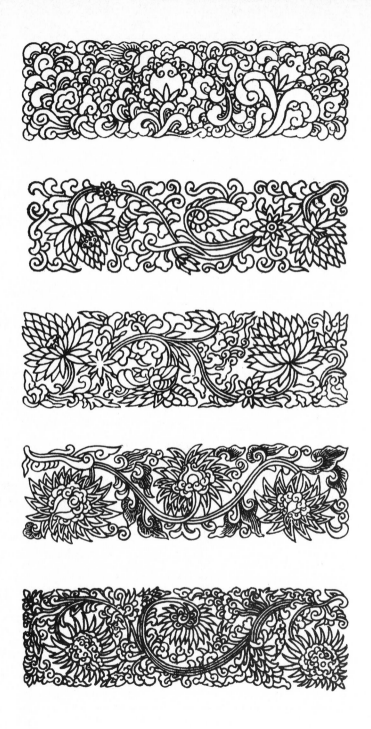

106

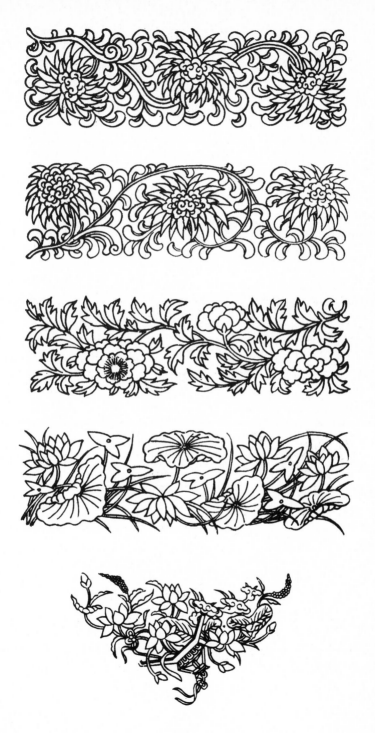

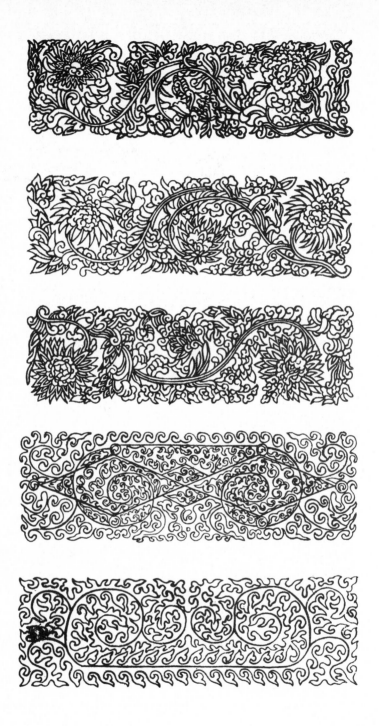

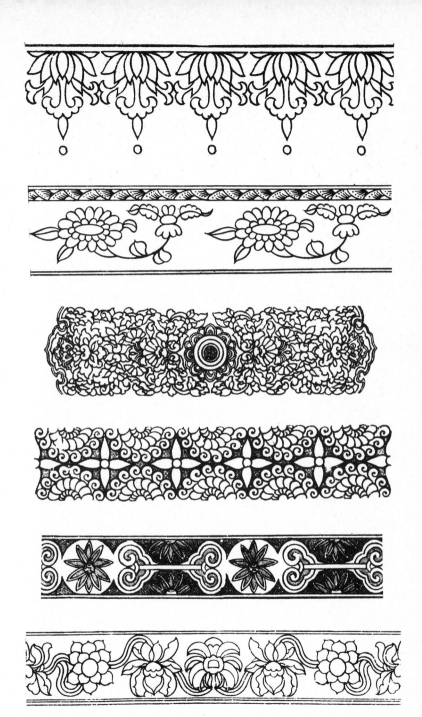

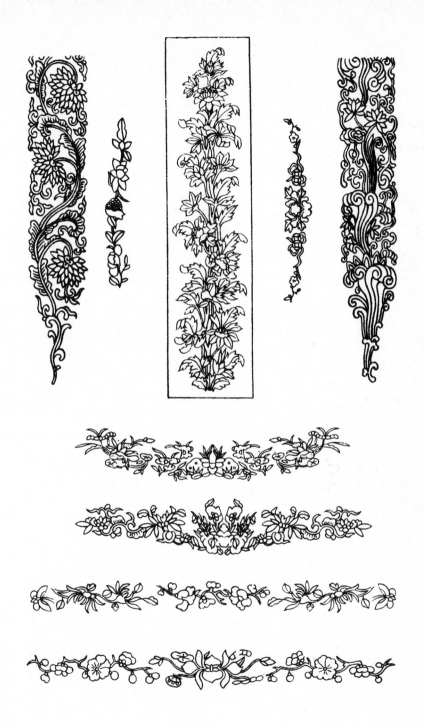

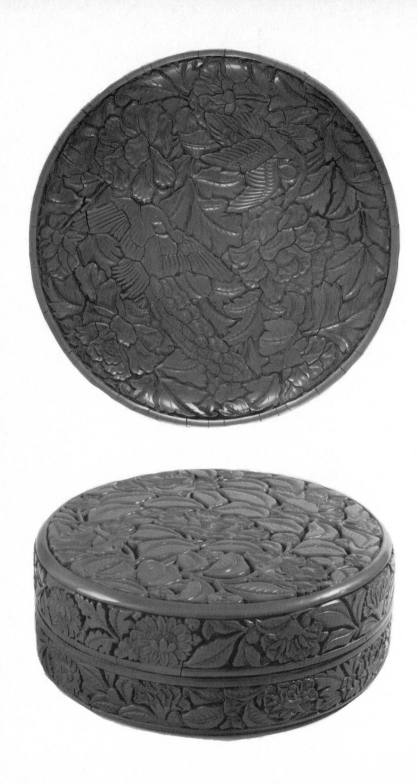

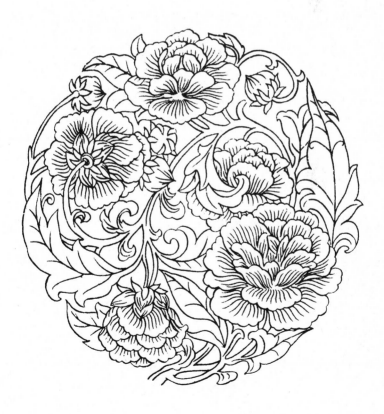

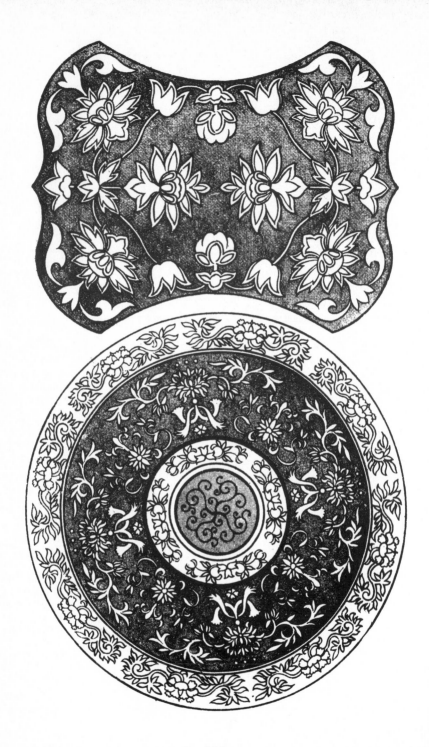

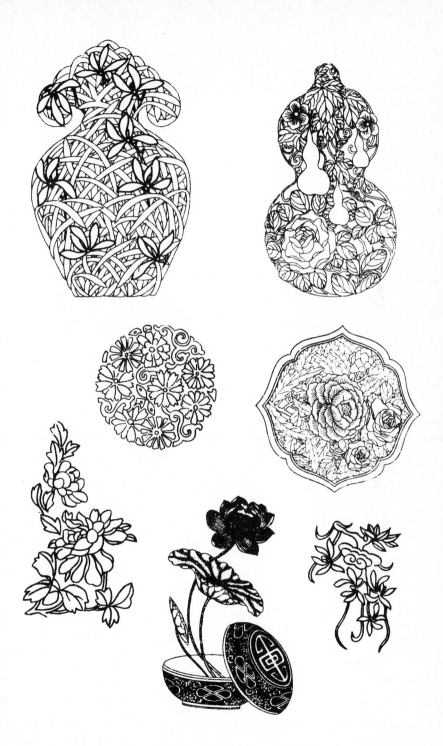

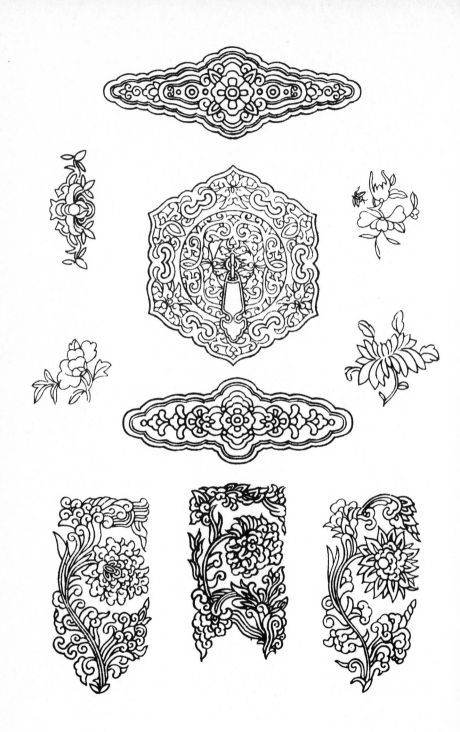

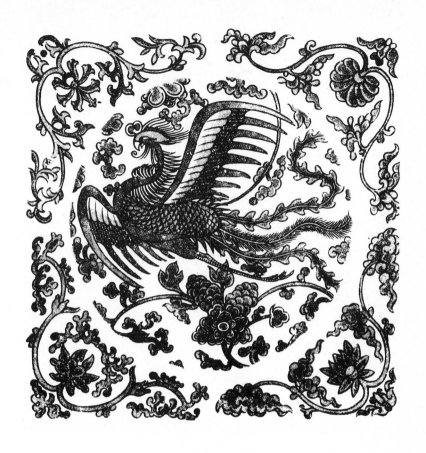

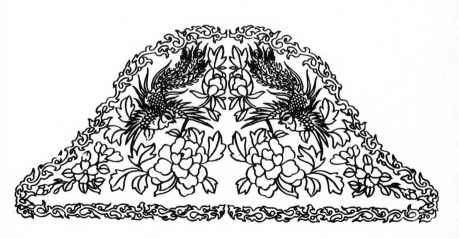

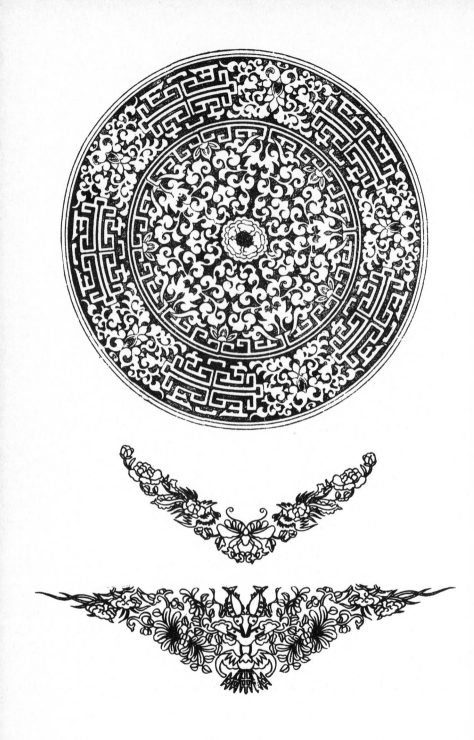

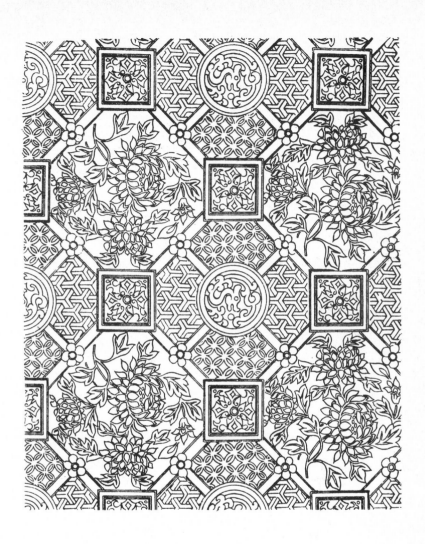

CLOUDS

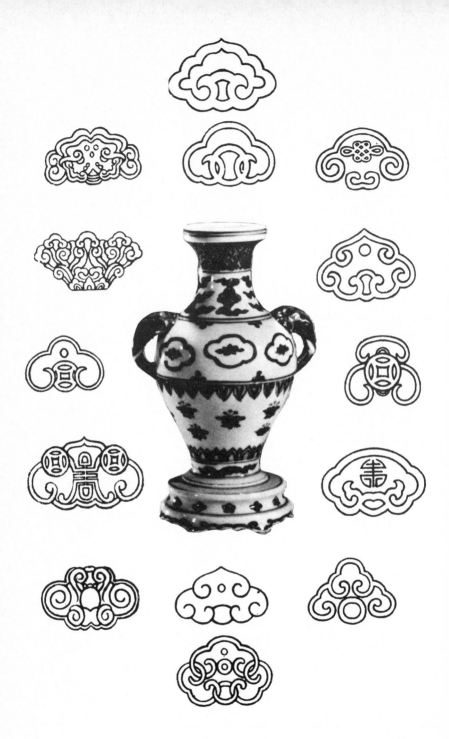

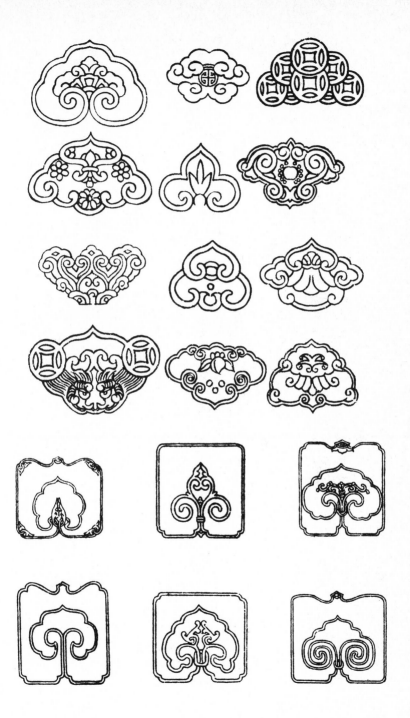

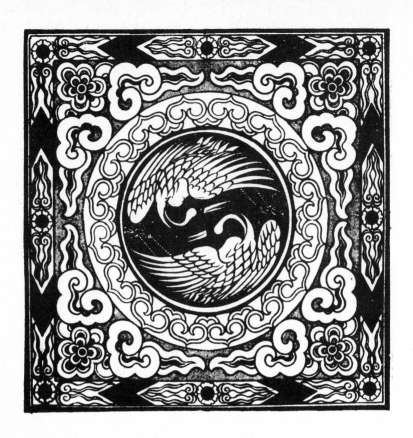

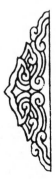

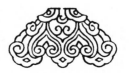

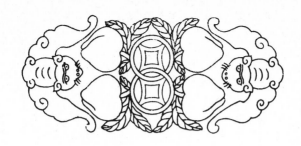

AUSPICIOUS SYMBOLS

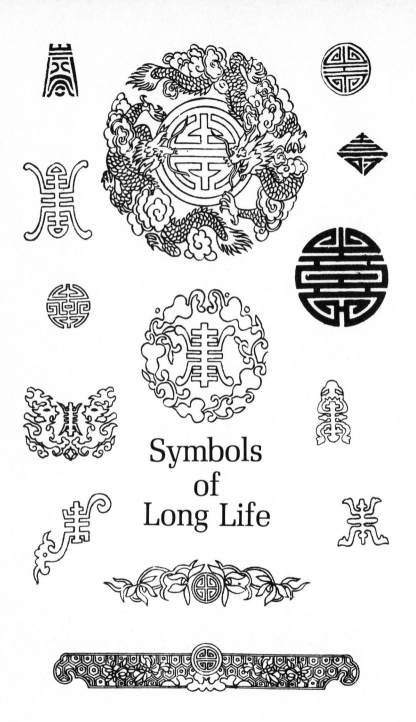

Symbols
of
Long Life

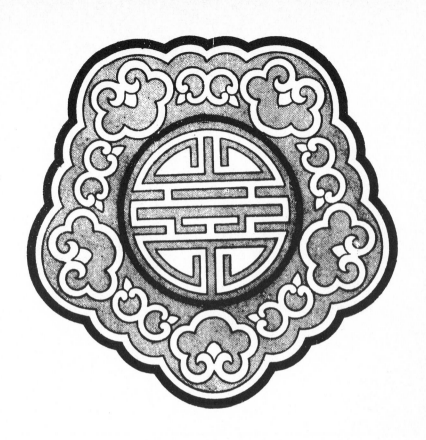

Phoenix and Peacock

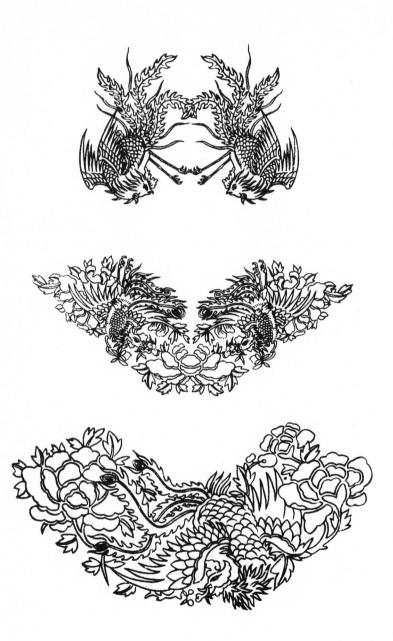

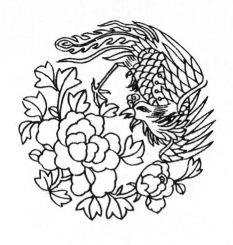

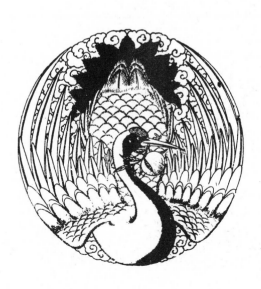

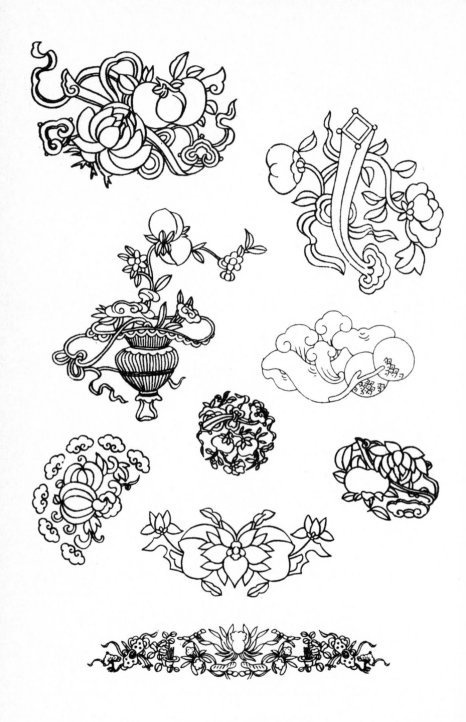

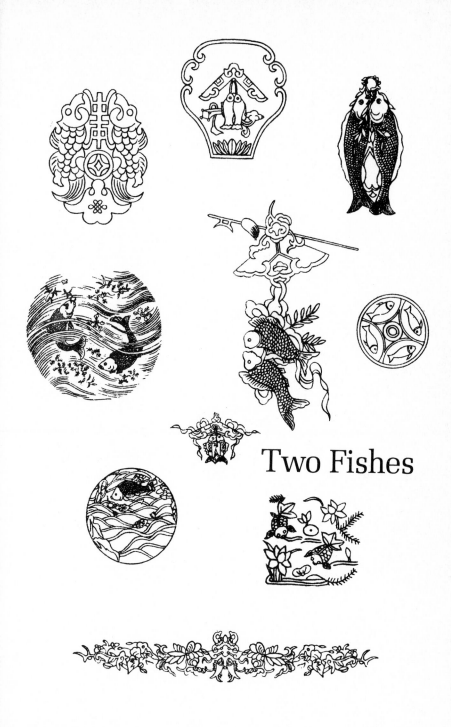

Two Fishes

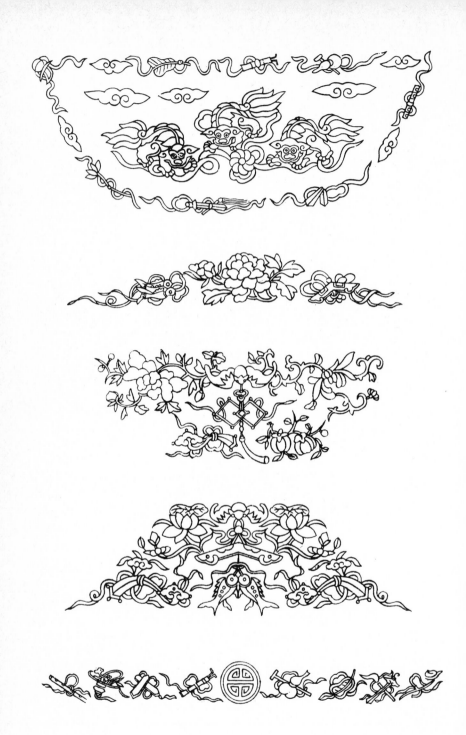

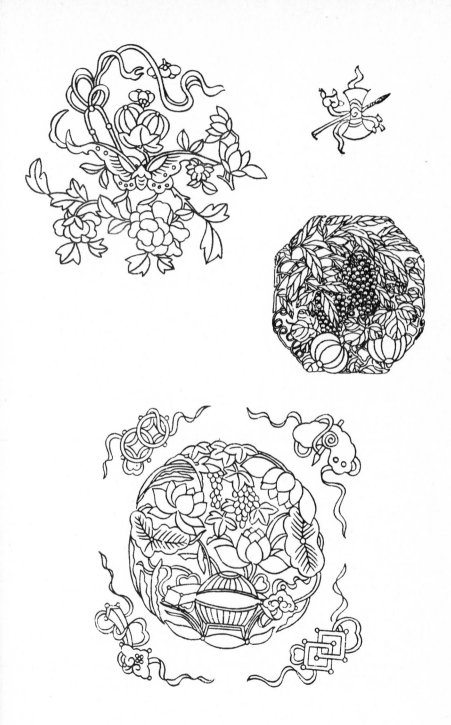

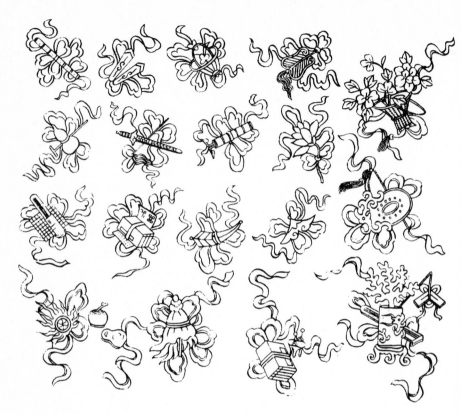

Taoist & Buddhist Symbols

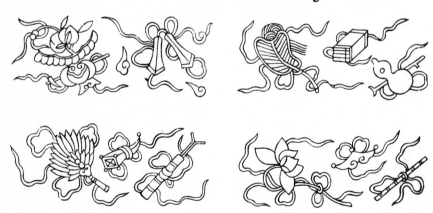

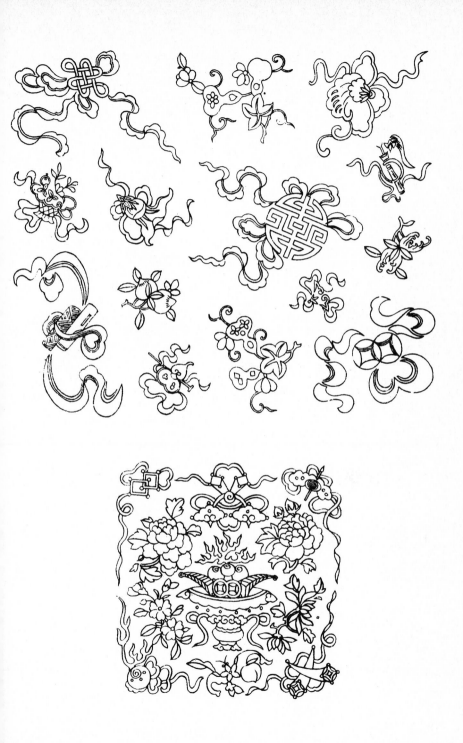

The Endless Knot

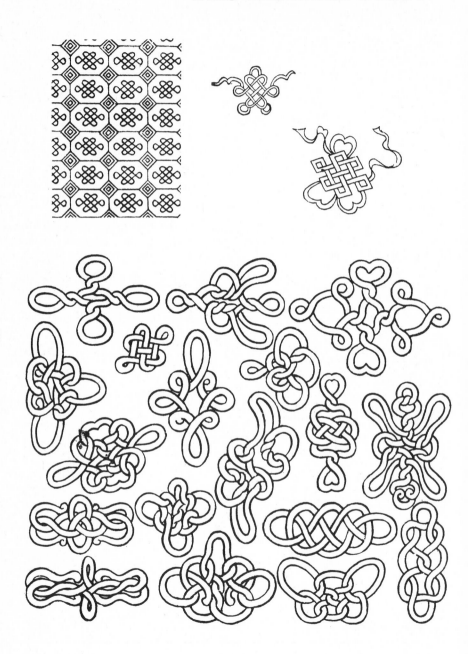

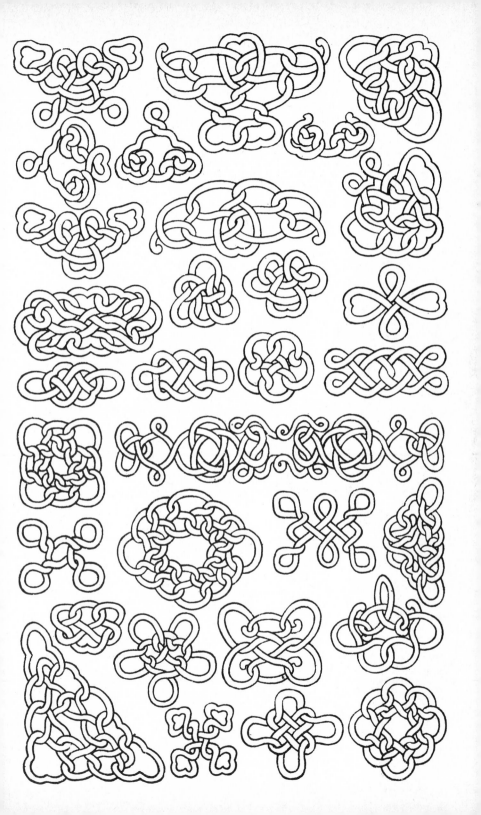

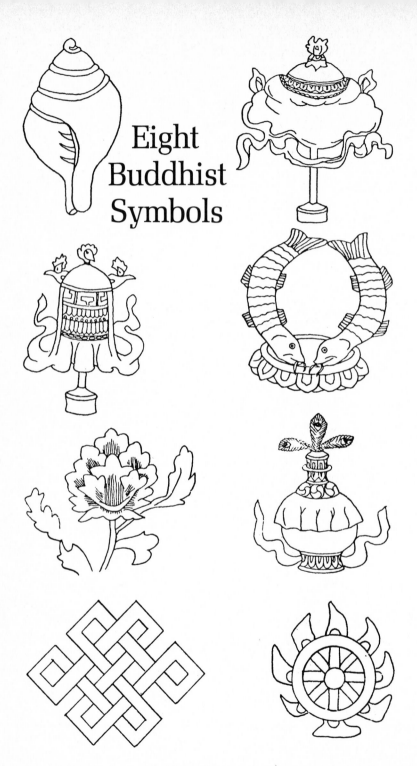

Eight
Buddhist
Symbols

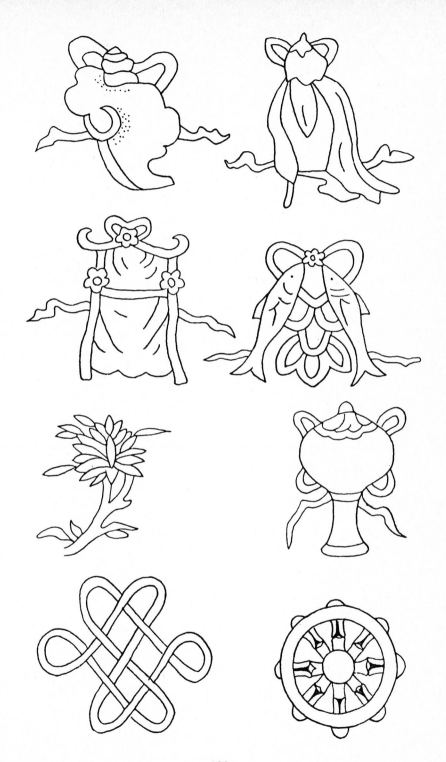

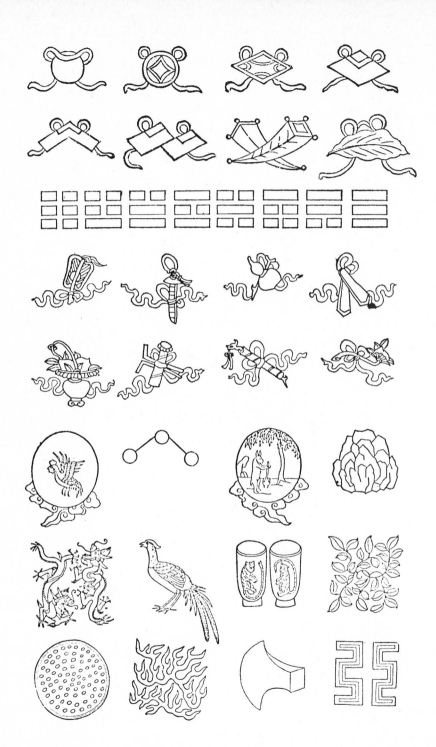

140

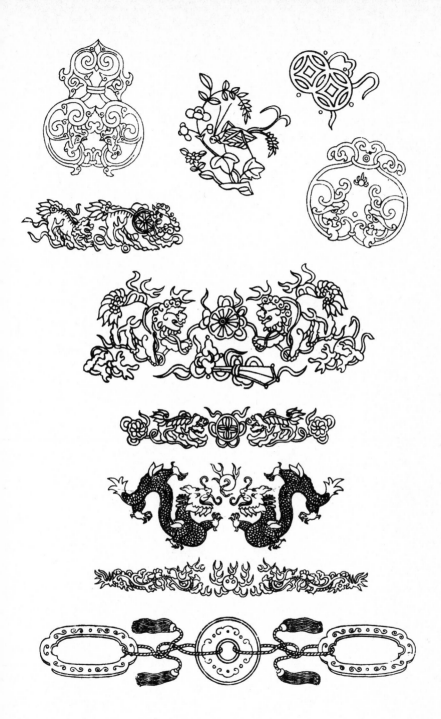

Cloud or Jui

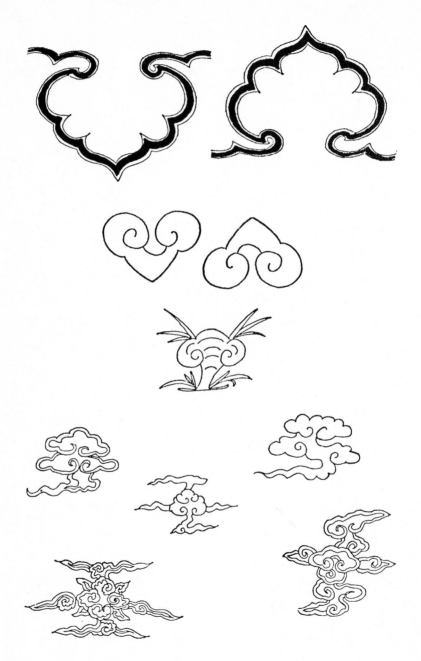

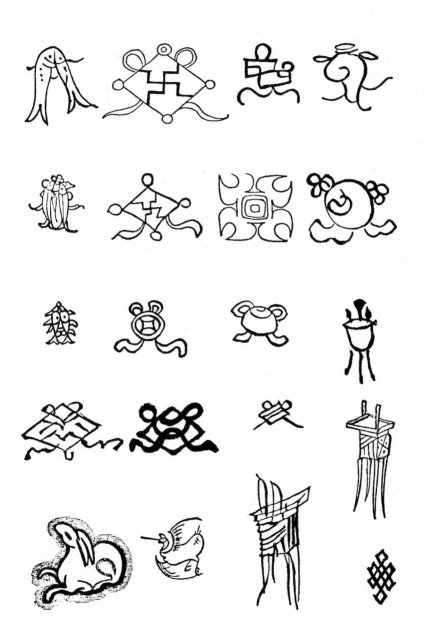

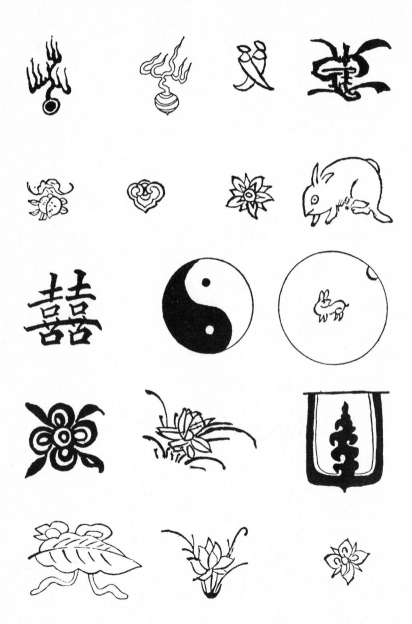